TERRY FROST

TERRY FROST

BRITISH ARTISTS

CHRIS STEPHENS

TATE PUBLISHING

First published 2000 by order of the Tate Trustees by
Tate Publishing, a division of Tate Enterprises Ltd,
Millbank, London SW1P 4RG
www.tate.org.uk/publishing

Reprinted with revisions 2004
First published in hardback 2015

A catalogue record for this book is available from the British Library
ISBN 978 1 84976 364 6

Distributed in the United States and Canada by ABRAMS, New York
Library of Congress control number applied for

Designed by Webb & Webb
Colour reproduction by DL Imaging Ltd, London
Printed in China by Prosperous Printing

Front cover: *June, Red and Black* 1965 (detail of fig.42)
Frontispiece: Terry Frost in his St Ives studio, 1961. Photo: Ida
Karr. By courtesy of the National Portrait Gallery, London

Measurements are given in centimetres, height before width.

ACKNOWLEDGEMENTS

It is a great sadness to many that, since
this book was first published, Terry
Frost has died, shortly followed by his
wife of nearly sixty years, Kath. I am
glad that he was typically forgiving in
his response to what I wrote and seemed
pleased with the end result. I owe a
great debt to Terry, who was generous
to me with his time and thoughts over
many years, and to Kath, for her warm
welcome and steady supply of cake and
biscuits. I am especially grateful to
Liz Knowles, whose willingness to
share her knowledge of Terry's works
and their whereabouts has proved
invaluable. I must thank the custodians
of public collections, the commercial
galleries, and the private collectors who
have provided access to their works.
Irving Grose at the Belgrave Gallery and
John Austin of Austin/Desmond Fine
Art have been particularly helpful in
tracing works or photographs. The co-
operation of Isobel Carlisle at the Royal
Academy has facilitated my research
and writing. I must thank everyone
involved in the production of the book,
specifically: Celia Clear and Mike
Tooby, for commissioning me to write
it, Jeremy Lewison for reading it, Izzie
Thomas for designing the first edition,
and Mary Richards, for her careful
editing. And to Jo, as always, thank you.

CONTENTS

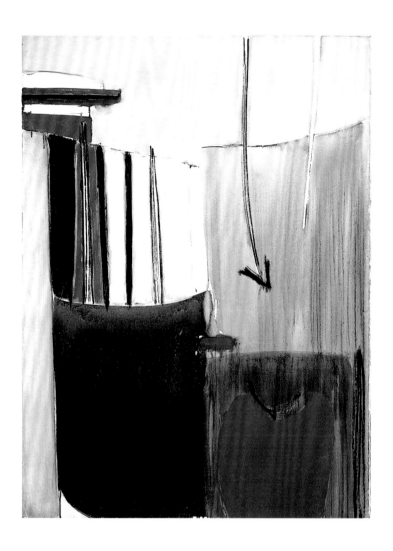

1
Umber and Grey
1960
Oil on canvas
182.9 × 132
Private collection

1 INTRODUCTION

'Draw happiness from oneself, from a good day's work, from the light it can bring to the fog which surrounds us. Think … "that was the best time".' [1]

FOR MANY YEARS, Terry Frost had this transcription from Henri Matisse pinned on his studio wall. Such a manifesto for optimism in the face of life's realities was the principal determinant for the art that Frost produced for over fifty years. It was also a characteristic of the man and of his view of the world. Though taking different forms at different times, his work consistently set out to bring pleasure to the onlooker, as Frost adopted Matisse's description of art as an armchair for the tired businessman. Colour was the main vehicle with which such pleasure was pursued. In life, too, Frost tended to look at the hopeful and the joyous, choosing not to dwell on the ugly or unhappy. For example, at a reunion of his friends from Stalag 383, where he was imprisoned for much of the Second World War, he was surprised at others' memories of brutality and hardship; his stories and recollections were happier and more humorous. It was not, he thought, that he had forgotten what had happened, but that he chose not to look at that part of his memory. [2] Frost, then, followed Matisse's dictum to always think 'that was the best time'; or, in the words of his favourite song, he adopted the philosophy that *Life's a Bowl of Cherries.*

Terry Frost and his art were very similar: colourful, gregarious, life-affirming. The white interior of his Cornish home, that looked down on

the harbour at Newlyn and across Mount's Bay, was punctuated with the
bright colours of the artist's paintings, sculptures, ceramics and Murano
glass, as the heads of sunflowers peered through the windows. At a private
view in a London gallery, his scarlet beret and glasses would introduce the
same splash of colour and sparkle that his work brought to the exhibition.
For half a century, Frost was one of the big personalities of British art, not
only as a painter and a teacher but also as a great raconteur and social
figure. As the painter John Hubbard wrote of him:

> There are a few people who make us feel good simply because we know
> they exist. To find another artist who not only gives this impression as
> a man but also, in his work, affirms the joy and importance of art is a
> rare piece of good fortune.[3]

Though serious and impassioned about his own art in particular and about
abstract art in general, Frost was irreverent and never precious. If asked
about a painting he would always have something to say and would speak
with enthusiasm: frequently, it would be 'the best I ever did', and many
works would have an anecdote that seemed to explain their genesis. 'I always
give them something,' Frost would say of those who asked about his work,
but there is a sense in which his explanations served to obscure as much
as they revealed. Just as the artist's bravado hid great technical skill and
intellectual ingenuity, so the association of a work with a minor, if humorous,
incident served to divert attention from the formal issues and ideas about art
and its function that underpinned Frost's activity. It is a theme of this book
that these explanations hide the more serious basis of the work.

Surveyed from a historical perspective, Frost's art and its meanings will
be considered in a roughly chronological pattern and in relation to the
structures and concerns of a broader artistic production. In a sense, the
artist's anecdotal explications will be assembled into a pattern in which
a broader philosophy and greater ambition may be discerned. Though
often humorous, his stories are not trivial, for Frost built them into a
working theory. His phrase 'memory and imagination' reveals the key to
his approach, as he imaginatively translated into paint the highly subjective
memories of a certain moment, a 'moment of truth'. From an early date
he found validation for this approach in the philosopher Karl Popper's
theories of the inherently subjective nature of knowledge and, later, in
Gaston Bachelard's writing on reverie. According to the artist, the other

essential elements were 'desire and discipline' – the latter being essential for the successful expression of the former. A dialectic of control and chaos will be seen as a persistent aspect of Frost's practice. To suggest such overarching frameworks for the artist's anecdotes is not to dispute the work's joyous and affirmative aspect, but rather to demonstrate how that side of it serves a more serious purpose.

The relationship between Frost's view of the world as 'a bowl of cherries' and his art is two-sided: on the one hand, by his own account, many of his paintings derived from moments of great joy – particularly in front of nature; on the other hand, through his work he sought to communicate those experiences, to create a similar sensation of pleasure in the viewer. Thus, to return to Matisse, the paintings themselves become sources of light in 'the fog which surrounds us'. What has often gone unnoticed is the apparent paradox, or dichotomy, in this situation: by investing his art with this role, Frost acknowledged the 'fog', the constant presence of darker forces that belied his optimistic philosophy. One can see the tension between pleasure and unhappiness (death, perhaps, or fear) emerging especially clearly in the work of particular periods.

What follows traces, firstly, the development of Frost's work from art school figuration to a constructivist abstraction. The latter is examined in the light of his connections with artists in St Ives and in London. In the later 1950s, we see him work in a more emphatic, gestural manner in which the compositional elements are more deeply buried. In the 1960s, he began to draw inspiration from a wider set of sources than landscape and nature, and the paintings became, generally, larger, flatter and more simple. This progressed to an even heavier commitment to colour as the principal element. Finally, we shall look at Frost's interest in, and visual responses to, poetry, and it is there, in Federico García Lorca's theory of the *duende*, that an explanation may be found for the dichotomy of his art. Like the colour theories which provided such an important grounding for his work, one can see recurrent dialectics in which dark is balanced by light, fear by humour, solitude by love. In 1994, Frost wrote an epigrammatic list of things he liked of which he had never made a painting; alongside 'the couple by the farmhouse and the apple blossom', one also finds 'crocodiles on the River Nile, or grenades hitting the branch of a tree and rebounding'.[4] 'The contact,' he wrote elsewhere, 'that one makes with misery, fear, cold, delight is always with you.'[5]

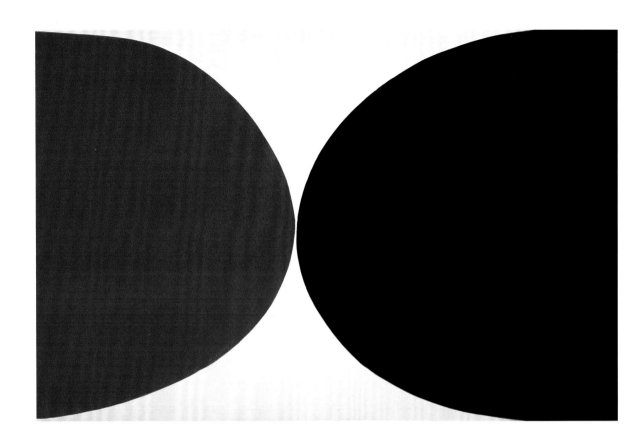

2
Red, Black and White
1967
Acrylic on canvas
198 × 259
Private collection

2 UNEXPECTED BEGINNINGS

THOUGH TERRY FROST'S CAREER started considerably later than that of many artists of his generation, he shared with them a belief in art's redemptive function that can best be understood if viewed against the backdrop of the Second World War. While others' careers were interrupted at an early stage, it is, perhaps, the greatest paradox of Frost's career that it was only the calamity of war which led him to become an artist at all. Despite his assertion that his art career began at the age of eleven as assistant editor of his form magazine, it was as a prisoner of war that he began to paint.[1] It was also, and more crucially, in POW camp that he found the first of a series of in-roads into the British art world through the painter Adrian Heath. Prior to these events, there had been little to suggest that Frost might have pursued an artistic career, coming as he did from the 'wrong' class.

Frost was born on 13 October 1915 in the Midlands town of Leamington Spa. His parents separated when his father returned from the First World War, and he was brought up by his grandmother with three uncles for company. Though one of them, a toolmaker, made drawings from photographs which Frost would copy, his main inheritance from them was an interest in sports, watching Aston Villa play football on Saturdays. Nevertheless, in retrospect, he identified expressions of his aesthetic sense

in a variety of unlikely situations. He left school aged fourteen and joined Curry's cycle shop, where he would dress the windows with coloured crêpe paper. Amid the seven jobs that he had, he was unemployed for a time and joined art evening classes in order to qualify for the dole. At a bakery he 'got quite decorative putting the crosses on hot-cross buns' and 'arty, because I used to put the jam and the cream in the doughnuts'.[2] At seventeen, he joined Armstrong Whitworth in Coventry, who were building warplanes, where he painted the electric wiring different colours and observed the painting of the RAF's red, white and blue target insignia. Finally, he worked for a radio firm, making small repairs. As a member of the Territorial Army since 1933 (he had joined a cavalry regiment because he enjoyed riding), he was called up as soon as war was declared in September 1939.

After spending time with the horses in the south of France, Palestine and Lebanon, Frost volunteered to join the 52nd Middle East Commandos. As a Corporal, he served behind enemy lines in Sudan (he later recalled, in particular, the new spatial experience of the jungle) before transferring to Crete. During the fierce and bloody battle for Crete in May 1941, the Commandos had to protect the evacuating Allied troops, and Frost's regiment was overcome by the enemy onslaught. After building roads for, and drinking with, the Germans, they were transported to Salonika in something like a slave ship. From there he was moved north to Poland before ending up at the huge Stalag 383 at Hohenfals in Bavaria.

Amid the enforced idleness of camp life Frost discovered 'the importance of the Arts when there is plenty of time, no money worries, no materialistic problems. Every person then became a reader or actor performer.'[3] It is unclear when he actually started to paint. In June 1944, he was able to send nineteen oils and four watercolours for exhibition in Leamington via the YMCA. Flight Sergeant R. Heard, a Leamington journalist who happened to be in Frost's camp, sent in a report for a local newspaper, which noted that Frost 'began painting in September last year', that is to say in 1943.[4] However, there are drawings dated earlier. Frost clearly took to painting quickly: at the time of his Leamington exhibition, he had already contributed to a Red Cross Society Exhibition and, despite telling Heard that he believed 'his *métier* is landscape', the artist later reckoned that he painted 'about two hundred portraits', because he was so good at getting a likeness that everyone wanted one.[5] At one time prisoners were allowed out on parole and he would gather flowers for still-lifes, but he later refused this privilege as having to return to camp was too upsetting.

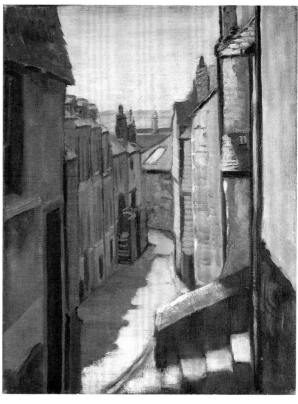

3
Portrait of Bob Allen
1943–4
Oil on canvas
Whereabouts unknown

4
Street in St Ives
1947
Oil on canvas
45.7 x 35.6
Collection of the
artist's estate

Conditions for painting were far from easy, as the equipment that came through the Red Cross was insufficient. Some paints were brought in by a friendly guard; brushes were made either from shaving brushes or horses' hair fastened to a stick with a piece cut from a sardine tin; sardine oil was used to supplement turpentine; Frost's easel was built from Red Cross parcel boxes; and he used a variety of supports. Heard noted that the artist's first watercolour had been 'done on a piece of blackout blind' and that he also 'used sugar bags and pieces of old palliasse covers as canvas'; the artist recalled that he would paint another prisoner's portrait in exchange for his pillow – using one side for the portrait and gaining the other for himself.

Frost joined a small painting group in the camp, but many years later he recalled a key encounter:

> One day I was busy drawing the back of a sitting figure … and I was being very hesitant, tentative, when I heard a voice behind me saying 'why don't you *put it on?*' and that was the first time I met Adrian Heath.[6]

Heath had studied at the Slade School in London and under the veteran
Newlyn painter Stanhope Forbes. Through him, Frost was introduced to
a small group of artistically-minded POWs and, for the first time, enjoyed
serious discussions about art. He learnt about Velázquez's use of geometry
and read *Lust for Life*, Irving Stone's romanticised biography of Vincent
van Gogh. Heath became a close companion in the camp and a hugely
supportive friend and adviser after the war.

The years Frost spent in captivity gave him more than a new pastime: they
provided him with a new view of the world around him. When he returned to
Britain, he was told that his family had thought him mad because he wrote to
them about 'the colours of the blue jays and the green of the trees'. But Frost said:

> you've got to understand that when you're on patrol or lying alone in
> a forward position or when you're a prisoner surrounded by wires, and
> there are birds so free and the trees and the clouds, it puts everything
> in perspective.[7]

He had not simply had nature revealed to him, but had uncovered a new
dimension to his perception. Over twenty years later he recognised the
prevailing influence that the war had had on him:

> In prisoner-of-war camp ... I got tremendous spiritual experience, a
> more aware or heightened perception during starvation, and I honestly
> do not think that that awakening has ever left me. There are moments
> when I can tune in to the 'truth', contact the other part of us and nature.[8]

By 1944, Frost had already stated his intention 'to spend two years
studying art ... and to take up painting as a career' when the war was
over.[9] Heath had recommended that he study at Camberwell School of Art
in London. On his return from Germany, however, his grant application
was refused because he had no School Certificate. In any case, he was
obliged to return to his pre-war job in Birmingham, which had had to be
kept open for him. He fell ill and believed the reason to be the fact that he
was not doing what he had intended:

> I'd promised myself that I'd paint. Because that's what I wanted to do
> and I didn't have to do anything else. After all I'd seen a lot of my mates
> killed. I'd seen all kinds of things.[10]

He hesitated because of family pressure and because he had married Kathleen Clarke in August 1945. During the war, Heath had advised him to go to St Ives and, with Kath and one tin trunk, he left the Midlands for Cornwall in May 1946.

The Frosts rented a caravan near St Ives in Carbis Bay, in the same road, it would turn out, as the home of Ben Nicholson and Barbara Hepworth; he had heard of neither. There was little money and he and Kath went to work in a guest house as butler and maid. After a time, they were able to rent a flat near the harbour, later taking over the whole house. For the next fifteen years 12 Quay Street would be home for them and six children: five boys, the first of whom was born in July 1947, and finally a girl, born in 1961. Unlike many of the artists around him, Frost had no private income and such a large family ensured that money would always be short. Nevertheless, his army gratuity and back-pay from the years in prison camp enabled him to attend the St Ives School of Painting in the mornings and to share with Bunny Stone (a painter of aircraft) the 7s. 6d. a week rent of a studio.

As Heath had no doubt been aware, it was at this time that St Ives was becoming established as a centre for modernist art practice, as younger artists settled in and around the town. They were attracted by the presence of Nicholson and Hepworth and united by their pursuit of a new art and of a reattachment to nature that might offset the effects of the war. Frost met the sculptor Sven Berlin and the painter Peter Lanyon, both of whom attended life classes at the School. Through them he encountered others, including the poet W.S. Graham and the painters John Wells and Bryan Wynter. Lanyon had recently returned from the RAF, and Berlin was recovering from the nervous breakdown that followed his experience of the Normandy landings. His Bohemian identity and belief in the recuperative power of an art close to nature epitomised much of the spirit of St Ives at that time. For Frost, in retrospect, the community of artists seemed to embody the character of post-war Britain. 'There ... was an air of confidence & of willingness to help others,' he recalled, 'a genuine belief in the spiritual side of art. Its responsibility to help towards the better life expected by all after the war.'[11] This spirit could be found more widely and it empowered Frost in his new career:

> The evil of war brought out the goodness in individuals. Class distinctions were undermined; everybody tended to try and help one another. People were trying to get through. The worlds of drama,

writing and painting, which before the war were very much a closed
shop, were opened up to people who never thought they could be a part
of them – people wanted to do things for real reasons.[12]

Frost met older, more conservative, artists as well as the young modernists.
As a result, he enjoyed artistic and material support of various kinds: Berlin,
'a brilliant draughtsman', would claim Frost as his first student; Lanyon, a
native of St Ives, introduced him to the landscape of west Cornwall and to a
new perception of the natural environment; Leonard Richmond advised him
to paint what people would buy – 'a polished table, a bowl of fruit, running
water and bridges', rather than the chipped teapot and tin of Vim he had
recently depicted (fig.5); and John Park, perhaps the finest of the local late-
Impressionists, 'would buy me half a pint of beer in the Sloop and when I
left I'd find half a crown and a packet of Woodbines in my pocket'.[13]

Despite his friendships with the artists of the Crypt Group – the younger,
modern-minded section of the St Ives Society of Artists – and an

5
Self Portrait with Vim Tin
c.1947
Oil on board
39.3 × 25.4
Private collection

introduction to Ben Nicholson, one of the leading modernists in British art, Frost's work changed little in the first years in St Ives. In the summer of 1947 he held a one-person exhibition – *Paintings with Knife and Brush by Terry Frost* – at George Downing's bookshop, where Nicholson, Hepworth, Lanyon and others also showed. From the display of thirty-two landscapes, portraits and still lifes, priced between £5 and £10, Frost sold £80 worth. His growing proficiency was also indicated by the fact that from 1947 he taught drawing and painting at the St Ives Summer School. By that time he had finally secured a place at art school. During a visit to the National Gallery earlier that year, he had bumped into some old friends from Stalag 383, one of whom told him that he was eligible for an ex-serviceman's training grant. This allowed him two years at Camberwell, which was extended to three. So, from 1947 to 1950 Frost spent the terms in London, living in Albert Bridge Road and later Beaufort Street, Chelsea, and the summers in Quay Street, working as a waiter in the Sunset Bar in St Ives.

Camberwell gave Frost a firm grounding in traditional skills and techniques and, as it would turn out, steered him towards an abstract art. The school was dominated at that time by the artists who had been associated with the Euston Road School before the war: William Coldstream, the head of painting, Claude Rogers, Victor Pasmore and William Townsend (dubbed in St Ives 'the Coldstream Guards'). It was known for its commitment to a figurative painting based upon the painstaking fixing of the subject's coordinates on the canvas. This system of objectively mapping the perceived object, which Frost called the 'drop one carry one' method, derived from the manner that Coldstream had developed in the 1930s. By this method, the artist measured the relative distances between individual features of the subject and translated those dimensions to the support in a series of 'ticks'. It had come out of a desire for an objective painting and was determined by its proponents' common admiration for Cézanne, which was reflected in their application of thin paint in short, regular strokes. At Camberwell, this style was complemented by tuition in such traditional skills as the preparation of boards, anatomy, Chevreul's theory of colour harmony and a considerable amount of art history.

Although he was one of the founders of the Euston Road School, Victor Pasmore was a maverick among the teachers at Camberwell. Frost later described him as 'my god, because Adrian Heath had already introduced me to his work'.[14] His painting had always been more Impressionistic than that of the other Euston Road artists, with looser forms and more succulent paint.

Since leaving the army in the middle of the war, Pasmore had been revisiting the history of modern art, working through the various styles and theoretical texts in order to find a way forward. In the late 1940s, this was taking him in the direction of an increasingly abstract mode of painting, to which Frost was inevitably drawn. At the same time, artists in St Ives, such as Lanyon, were formulating an abstract art that synthesised constructivist forms and principles with natural sources. By the time he went to Camberwell, Frost recalled, he had already 'fiddled about a little bit … started to get interested in what the boys [Lanyon *et al.*] were trying to do. Although I was still doing straight forward stuff myself, I was very tempted by what they were doing.'[15] He was inevitably encouraged in this direction by Pasmore. On one particular day, Frost was working in Pasmore's class:

> [Pasmore] said: 'I see you've finished already'. I'd been there about half an hour. And I said, 'Well this is what I really do', and I showed him the other side of the board. He said, 'Come on inside'. He said, 'don't come in here any more. Go round the National Gallery and go round the modern galleries'. I said, 'But it's taken me two years to get a bloody grant and I have to sign the book.' He said, 'get somebody else to sign it.' And that was my first meeting with the great man, who said don't come here any more … That was my advice from Victor Pasmore.[16]

Though he continued to attend the school, Frost did immerse himself in the study of the Old Masters. His appreciation was clearly influenced by the fascination with geometric proportion that was common to all at Camberwell. The interest in such ratios as the Golden Section, or the Fibonacci Series of numbers, was passed from the followers of Coldstream to the abstract artists who would emerge from the school. Together, they read such key texts as Jay Hambidge's *Practical Application of Dynamic Symmetry* and Matila Ghyka's *Geometry of Art and Life*, which offered means of analysing the composition of paintings by such artists as Rubens and Piero della Francesca, and, later, for generating their own compositions.

For some time, most of Pasmore's paintings, though still strictly representational, had been based upon the subdivision of the canvas into thirds, quarters, fifths, or by use of the Golden Section (the ratio of 1:1.618). In 1948 he showed his first completely non-representational works – collages of newsprint and other papers and cards cut into a variety of squares, rectangles and semicircles and assembled in a manner heavily indebted to

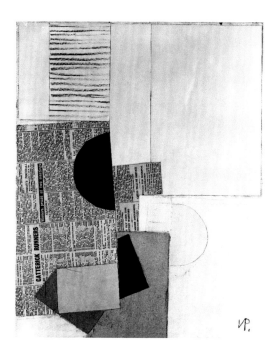

6

Victor Pasmore

**Abstract in White,
Grey and Ochre**

1949

Pencil, paper and

newsprint on canvas

50.8 × 40.6

Tate

cubist collages (fig.6). This departure was seen as a major event for British art and had a significant effect on Frost. He remembered 1948–9 as a time when, through Pasmore's influence, he became increasingly conscious of the abstract qualities of paintings: 'The meaning of composition became much clearer … helped by the general influences of the day … [and] certain of the old masters.' Of the latter, Piero and Rubens stood out, while Frost was also impressed by his reading of Kahnweiler on Juan Gris and Apollinaire on cubism. However, if he had been disposed towards abstraction for some time, he seems to have had trouble in 1949, and perhaps earlier, as he negotiated between two different modes of painting.

During 1948, Frost's painting became more stylised and began to show a greater concern with areas of colour than with illusionistic form defined by line and tone. A key transitional work was a portrait of the Camberwell model Miss Humphries made from drawings rather than from life (fig.7). Frost recalled returning to the studio which he now had in Heath's new house in Fitzroy Street:

> I got out all the drawings that I'd done of Humph … and I decided to paint her, not from life but from my drawings. That became one of the

7

Miss Humphries

1948

Oil on canvas

76.2 × 63.5

Collection of the

artist's estate

most important paintings of my life. I had to stop being descriptive and start being pictorial. I had the drawings but I had to *make* the painting. And that's when you realise that you have to go back and make more drawings ... for more information, more form, more reality.[17]

Thus, for the first time, the artist sought in his work a reality that was not synonymous with visual reality as defined by realism in painting.

Only a few of Frost's 'transitional' works survive, but they show how external subjects were reduced to the most simple forms to achieve a painting in which representation and abstract pattern were carefully balanced. Judging by these works and Frost's letters of the time, it seems that the move towards abstraction was fitful, suggesting that he was as unsure of its desirability as of its processes. 'These days I work entirely for myself,' he told a friend towards the middle of 1949, 'abstract being the phase I'm going through now. I am completely free to make what shapes I like and to invent what colour I like not being bound by any visual image.'[18] He later said that it was colour that posed a major problem in his development of an abstract art:

I could do the geometrical division of an area, say if you have a shape which was related to another shape, because it was running through the set of proportions, but of course what was worrying me was, once you put the colour in the shape, that was it, it was a different shape. It took a different plane. It couldn't hold the surface anymore.[19]

A painterly finish seems to have offered one means of making sure the surface held together.

He had not abandoned figuration, however, and reported going 'through one of those horrible blank periods, torn between making myself paint a still life in the representational manner or carrying on with the fight and flogging myself until I squeeze out another abstract'.[20] And, a little later, he was 'as confused as ever, but have made some advancement'.[21] Indeed, he seems to have reverted to representation:

I am now mixing or should I say am able to work on representational and abstract art. This I feel is much better for me, for as you well know I was always moved by things around me. Though of course the abstract and subjective work that I have spent so long on has been very valuable

to me. For one thing I did not know that I had any real imagination
or deep subjective feeling and I have been able to develop those senses
enormously. Now I have to battle on and find the method in which
I can express all these emotions best. Whether it be by abstract or
representation remains to be seen.[22]

Not long before he left Camberwell in 1950, he told Ben Nicholson that
his work was 'all over the place now … I am torn between abstraction
and figuration … I've done a straight up and down Euston Roader, in the
best Camberwell tradition.'[23] Only one of the numerous abstract works
produced at that time survives, but it and Frost's explanation of its genesis
reveal something of this uncertainty as well as setting the work up as an
anticipation of those that would follow.

For their summer assignment in 1949, Claude Rogers gave the students
two themes from which to choose: 'Joseph's Coat of Many Colours' or
'A Madrigal'. Frost chose the former but, on researching it, he found that
expert opinion of the story's meaning differed. So he turned to the other and
discovered W.H. Auden's *Madrigal*, a short poem describing a miner's return
to his lover, that begins 'O lurcher-loving collier, black as night'. The rhythm,
the use of colour imagery – 'and to his black be white' – and the fact that
the girl was called Kate, drew Frost to the poem. He subdivided the canvas
'with the Golden Section and the square so that every geometrical shape
was related to every other shape'. Having achieved this disciplined structure,
he translated the space of the poem to the flat surface, moving through the
picture like an abstract narrative, and using colours to symbolise emotions:
'I pushed in the warmth when he came up from the mine to meet Kate. It
was pretty obvious he wasn't coming out of the bloody mine to have a cup
of tea.'[24] The artist, nevertheless, recognised that the picture's colouring is
that favoured at Camberwell: 'bottle green, maroon, deep brown, and very
much like the dullness of the life room.'[25] Unlike the work of Coldstream and
his followers, however, *Madrigal* (fig.8) is generally quite thickly painted,
with the evident brush-strokes introducing a further expressive dimension.

Madrigal negotiates an awkward position between the non-figurative
object which Frost's account suggests – determined by, but not illustrating,
Auden's poem – and the depiction, albeit stylised, of an imagined
landscape. Despite the symbolic use of colour and the movement around
the canvas according to the story of the poem, one can clearly discern in

8
Madrigal
1949
Oil on canvas
71 × 91.4
Leamington Spa Art Gallery

the work an horizon, suggested by the pale 'sky' set around the darker triangles, that are reminiscent of slag heaps. A similar ambiguity was seen at about the same time in works by Pasmore, which were based upon a pattern of squares and triangles determined by geometrical formulae, but were suggestive of landscapes in their format and, on occasion, their titles. While an ambivalent attitude to abstraction was characteristic of much British art of the time, there was also a close parallel to poetry, perhaps, in the combination of formal rules with symbolism, and emotional and suggestive imagery. The combination of formal discipline and the narration of actual spatial experience would become the major dynamic in the work that first secured Frost's reputation after he left Camberwell.

9 [above left]
Peter Lanyon
Porthleven
1951
Oil on board
244.5 × 121.9
Tate

3 THE ABSTRACTION OF EXPERIENCE

THREE YEARS AT CAMBERWELL had not reduced Frost's contact with St Ives. His family had remained in Cornwall, so he would return for the vacations and he went back when his studies were complete in 1950. In February 1949, the St Ives Society of Artists had split and a breakaway group had founded the Penwith Society of Arts in Cornwall. Though the new society included both modernist and traditional artists, it was dominated by Hepworth and Nicholson and the potter Bernard Leach. Consequently, it came to be seen as the representative of modern art in St Ives, the result being Arts Council support and a rather tortured history of bitter disputes over its role and constitution. Not long after its foundation Frost was invited to join but, he told a friend, had 'so far declined because I don't think they would accept my work'.[1] He sent paintings for exhibition in 1950 and finally joined in 1951.

10 [opposite right]
Walk Along the Quay
1950
Oil on canvas
152.5 × 56
Private Collection, on loan to
Graves Art Gallery, Sheffield

It is likely that the original invitation was prompted either by Lanyon – the first Press Officer of the Penwith (though later to resign from the society) – or Nicholson, with whom Frost had maintained a correspondence while at Camberwell. Nicholson was very active in the promotion of younger artists who he felt followed a path akin to his own, and he became an important supporter. He encouraged influential friends to look at Frost's work; for example, Philip James, Head of Visual Arts at the Arts Council, bought a painting of Porthmeor

25

Beach. Nicholson also interceded to secure for Frost one of the spacious
Porthmeor Studios which faced onto St Ives' Atlantic beach. More importantly,
he seems to have persuaded E.C. (Peter) Gregory, art patron and director of
the publisher Lund Humphries, to pay Frost's rent in exchange for paintings.[2]
At the same time, in 1950, along with Denis Mitchell and John Wells, Frost
was taken on by Barbara Hepworth, who was showing at the Venice Biennale
that year, to assist with her carving, most particularly with the monumental
Contrapuntal Forms, her commission for the Festival of Britain (1951).

By then, St Ives was widely seen as one of the most exciting centres of
contemporary art in Britain. Nicholson and Hepworth were acknowledged
as senior figures with international reputations, while younger artists such as
Lanyon, Wynter, Wells and Berlin were exhibiting in London. The presence in
the summers of Patrick Heron, a painter then best known as the art critic of
the *New Statesman and Nation*, helped to ensure plenty of coverage for local
events. A new art was emerging that was intrinsically linked to this group of
artists, their lifestyle and their environment. Though they can be divided into

11
Coastal Figure, St Ives
1952–3
Oil on board
101.5 × 305 cm
Private collection

different strands, they were united in the pursuit of a modern art that was in tune with nature, as a substitute for the idealism of pre-war modernism which had been washed away by the tides of the war and its aftermath. The romantics, such as Berlin and Wynter, rejected the abstraction of Nicholson and Hepworth and pursued a representational art closely tied to their knowledge of natural process and environment. Alongside them, Wells and Wilhelmina Barns-Graham adopted Nicholson's practice of scraping the canvas, or board, to achieve a gently textured surface that seemed to mimic natural weathering and so provided a parallel to the abstract, organic forms of their paintings.

Like them, Lanyon had developed under the shadow of Nicholson and the Russian constructivist Naum Gabo, who had lived in St Ives from 1939 to 1946. By 1950, however, Lanyon was developing a distinctive approach to the painting of landscape that escaped the single viewpoint and incorporated the artist's physical experience of a place in real time. A little earlier, he had described how one's movement through a place and perception of it – through all of one's senses – should be translated into painting's two dimensions.[3] Thus,

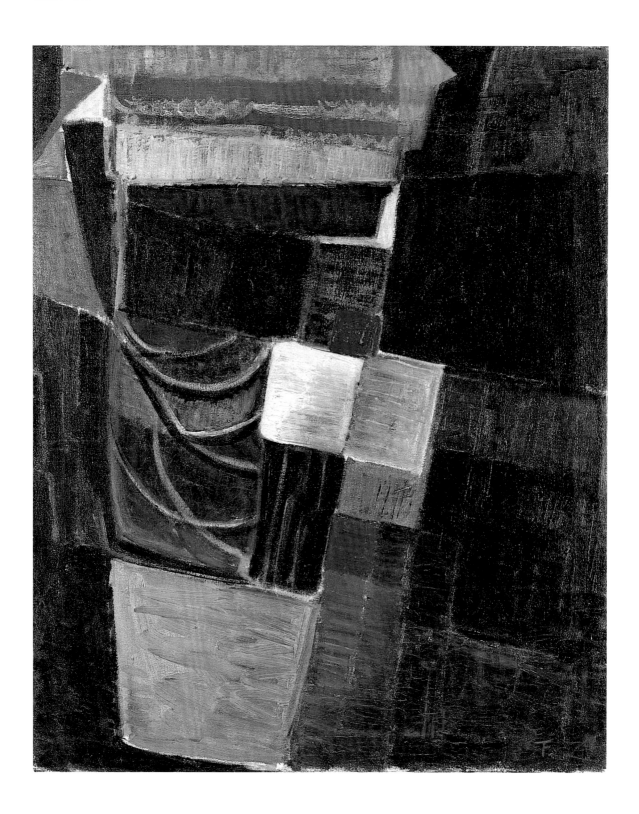

he sought to apply the multi-directional character of cubism to the space that surrounds us (fig.9). It is not surprising that Frost should have been attracted to such an idea, as he had come close to a similar position already. It was at Camberwell that he had realised

> that the 'more than one viewpoint' outlook was very important ... From then instead of copying nature (or a subject) the important thing became how to use all I had learned from nature in terms of paint on a flat surface and bring about an analogy to what I saw and <u>felt</u> ... I was able to be free, to walk about & see for myself, to probe & feel in a much less eclectic manner the structure & growth of nature.[4]

In discussing the morning strolls that led to his first key painting, *Walk Along the Quay* (fig.10), Frost spoke of the 'walk through space [as] an experience and not a window perspective thing at all it was a Time experience'.[5] This statement closely echoes Lanyon's stated desire to 'get beyond the window', a position that reflected his belief in the need to immerse oneself both in the social reality of a place and in the reality of one's own phenomenological existence.

Frost recorded the importance for him of his journeys into the Cornish landscape with Lanyon, who was not only very aware of the history of Cornwall and of specific locations, but also sought to experience a place physically in as many ways as possible. 'Peter would drive me all over the place, along the coast and up on the moors ... he taught me to *experience* landscape ... so you lay down in the landscape, you looked up into a tree ... you walked over the landscape so that you understood its shape, you looked behind rocks so that you knew what their shape was all the way round and what lay beyond them, you walked over the hills and the high ground so that you knew what was above and below you, and what was above and below the forms you were going to draw, and all the while you're feeling those forms all through, you're travelling through the landscape.'[6]

Though Frost described *Walk Along the Quay* as 'a kind of revelation',[7] he also suggested that one of these trips with Lanyon stimulated an earlier, but similar, work: *Mullion Cove* (fig.12).

At Mullion, a small harbour on the Lizard peninsular, Frost was especially struck by the black rock, in particular a single huge monolith that rises to one side of the harbour.

12
Mullion Cove
c.1949
Oil on canvas
76.2 × 63.5
Whereabouts unknown

There were black rocks and blue sea, and a little quay jutting into the sea, and a slanting lamp-post to the side, and sea water smashing over the rocks. So when I did my blue and black painting I was walking along that quay to look at the rocks.[8]

13

Terry Frost on Smeaton's Pier, St Ives

c.1953

The two artists' methods were, however, very different:

Peter ... was so expressionist while I was very tight-arsed because of Camberwell. He just roared into his drawing ... I walked round and round, trying to draw the experience of the landscape in a single moving line ... I would get out my geometrical divisions and then find a way to express something like Mullion Cove by putting colour references to what I'd seen and what had moved me, blue black where the rocks are wet, and the little bay at the bottom, and so I build up and build up until I rediscovered my experience.[9]

While the geometrical structure and the suggestion of a horizon are similar to *Madrigal*, the series of arcs introduces a new freedom of form and an idea of the subject, suggesting the slackened mooring ropes of boats at low tide or the flow of incoming waves.

As if reworking the clichéd harbour views of earlier St Ives painters, Frost produced a series of works based on boats in harbour. The majority of the first of these pursued one of two themes: either the *Walk Along the Quay* or the *Movement* paintings. In fact, both of these groups and others that followed were determined, fundamentally, by movement: either the artist's movement through space translated into two dimensions, or the observed movement of an external object.

The earliest of these groups is the *Walk Along the Quay* series, named after the major work of the series, though it was not the first and certainly not the last. The story of its origin in the artist's daily observation of boats in St Ives harbour has frequently, if inconsistently, been told, but bears repeating for the insight it gives into Frost's approach.

> I never thought about it at the time, I thought of the title after I got the idea, I mean I had been walking along the quay every morning … it was quite a simple experience. I just happened to notice that the boats were there with a different colour on when the tide was out and they were all propped up and there I saw all those semi-circles propped up on a stick … Things were happening to my right and beneath my feet … The strange feeling of looking on top of boats at high tide and at the same boats tied up and resting on their support posts when the tide's out … So after all this I had no problem in finding out how to paint 'Walk Along the Quay'. The size of the canvas was suggested to me by one I happened to have. It had to conform to my idea, the walk, so it was long, like the quay (the pier past Smeaton's lighthouse) and narrow. Everything was happening below me so I think for the first time I managed to paint up the canvas or along the canvas, like I walked along the quay, in fact I just walked up the canvas in paint.[10]

That such anecdotes only half explain the source of such images is demonstrated by the very large *Coastal Figure, St Ives* (fig.11) which was conceived as a horizontal description of a walk along the coast from St Ives to Zennor, a few miles to the west. In this narrative work Frost came closest to Lanyon's conception of landscapes of experience.

Of course, the progress from experience to painting was nothing like as smooth as this account makes out. In 1955, Frost gave a clearer idea of the concept's development:

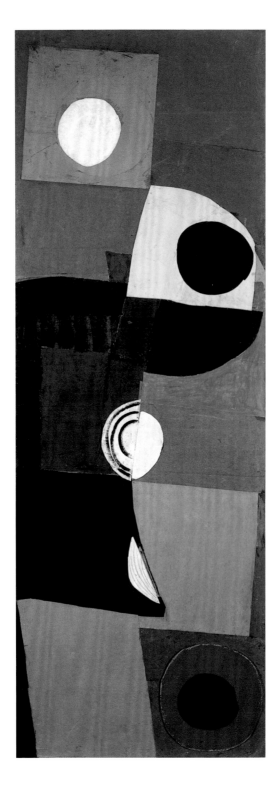

14
Moon Quay
1950
Collage on board
152.5 × 54.5 cm
Peter Nahum at the
Leicester Galleries

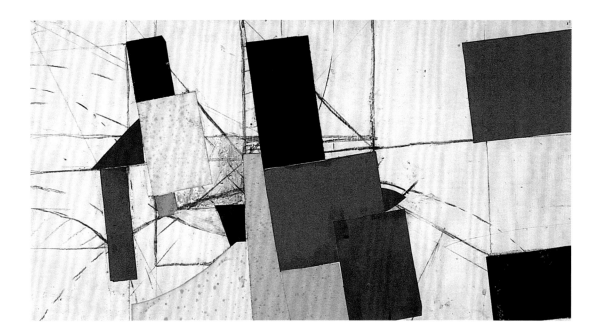

15
Collage
1950
Oil, charcoal and
collage on board
40.5 × 75 cm
Pier Art Gallery, Stromness

I drew it for weeks, walked it for about two years I suppose, finally worked it in collage up and down the canvas, no geometry but quite intuitively, though colours and shapes were evocative rhythm too. Then I put it into paint and it became the first *Walk Along the Quay*.[11]

It is, perhaps, significant that the idea for *Walk Along the Quay* was expressed initially in collage, a practice first used by Frost in 1950. He was undoubtedly stimulated by Pasmore's work in that medium (fig.6), and one cannot help but observe the recurrence in Pasmore's collages of the semicircle which became a staple of Frost's work, a welcome reminder of its formal, as well as representational, function. Frost attributed his adoption of collage to his work for Barbara Hepworth:

> working for Barbara made me think that the whole thing was totally illusionistic, painting, and made me lose confidence, I think, because if you're making actual shapes there's something marvellous about it.[12]

The necessity to decide upon a form from the start, without the ability to turn back, along with the abandonment of paint's tone, modelling and texture, marked a fundamental move away from the practice taught at Camberwell.

33

If the large *Moon Quay* (fig.14) is decorative and clearly related to the *Walk Along the Quay* series, *Collage* (fig.15) is far rougher and more challenging. The tension between a pre-conscious design and an improvisatory approach is suggested by the loosely drawn, but nonetheless controlling, geometrical charcoal lines that underlie the composition. Its simplicity suggests that Frost had such works in mind when he described the liberating function of his experiments with different techniques and media. Just as 'the pure division of the rectangle by the use of geometry' had freed him 'of other people's vision', so, in order 'to drop the tricks of tone illusionism', he said, 'I used paper [coloured] black, grey, brown and white'.[13] In a strange reversal, his new practice gave him a refreshed perception of the world around him:

> Relying on proportion and colour for space creating and balance and rhythm for excitement, at last I was able to walk about and see things for myself … I drew and wandered around, made collages, carved for Barbara Hepworth and for myself, made constructions, painted the occasional realist type picture, but always with a desire to use colour.[14]

Though completely 'realist type pictures' are rare, Frost's various harbour paintings did show a varying commitment to abstraction. *Movement, Green and Black* (fig.16) uses a pattern of curved lines to depict, fairly literally, the movement of water around the edges of a harbour mouth. Once again, this was a device which had a formal precedent in the work of Pasmore, whose art around 1951 was dominated by spirals and interlocking patterns of lines, which have been related to drawings he made of Porthmeor Beach in 1950. Nevertheless, its literal function is more apparent in Frost's work. In contrast, at the same time he produced some paintings in which the original motif is hard to discern. The colouring and some of the forms of *Yellow and Black Movement* (fig.18), for example, may suggest a scorching summer sun, but beyond that it may be seen as a non-figurative piece.

Green, Black and White Movement (fig.17) was the first of a series of paintings based on the movement of moored boats on the water. In it, Frost once again brought together the formal discipline of a geometrically subdivided canvas with a less formal, allusive representation. Along the edges of the canvas, he measured and marked a series of proportions: quarters, thirds, halves, the Golden Section. These provided the end points for the various horizontal, vertical and diagonal lines that traverse the field and define the areas of different colours. According to the artist, the arcs were achieved

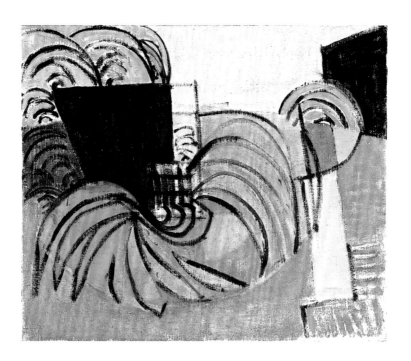

16
Movement, Green and Black
1952
Oil on canvas
50.5 × 61
Arts Council Collection,
Hayward Gallery, London

by stretching a piece of string along the ruled lines and allowing it to slacken off. While this account highlights the formal element of the painting, the forms obviously refer to moored boats bobbing on the sea, with some of the straight lines coming to suggest the ropes that tether them. This work had technical problems which Frost tried to alleviate by scrubbing the canvas in the bath. Though the thin colouring may be the result of this rough treatment, its evocation of the sea and creation of a sense of shallow depth elicited specific praise from Patrick Heron a few years later:

> The limpid, swift clarity of the scissoring banana-forms in 'Movement in Green, Black and White', 1951, evokes the bobbing of moored rowing-boats in St Ives Harbour. Even without colour, one feels the water surface (which now admits the eye deep into submarine gloom, and now rebuts it, keeping it *at* the surface) implied throughout the surface of the picture. All the shapes stop the eye, as a bat stops a ball, cleanly and finally at a given depth in the imagined space in the painting.[15]

The suggestion of depth, and its refusal by solid forms, fitted Heron's belief that the best contemporary art concentrated on the creation of a shallow pictorial space while preserving the integrity of the picture plane. It was also

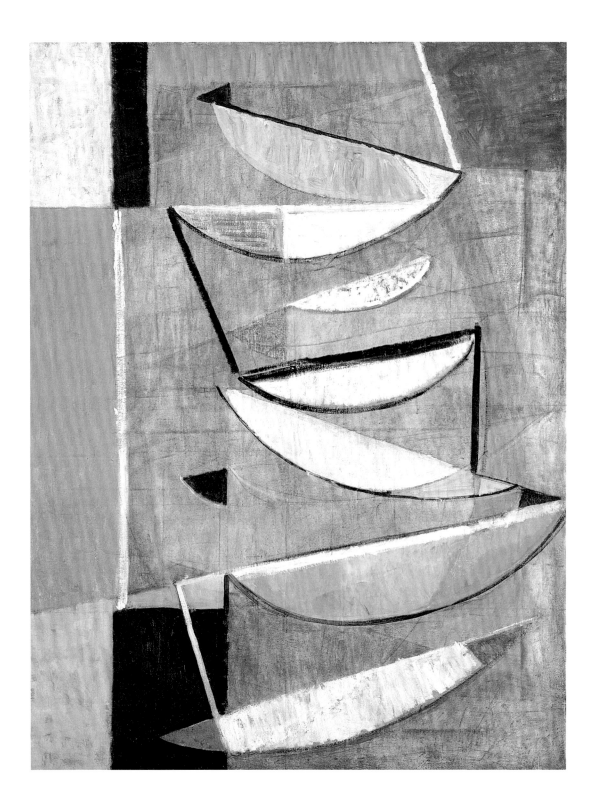

consistent with the view, that he maintained until 1956, that art should remain figurative, even as formal issues became its primary concern.

Frost's delicate negotiation of abstraction and figuration did not suit others so well. In October 1952, his first one-person exhibition in London, at the prestigious Leicester Galleries, attracted appreciation of his ability tempered by predictable hostility to abstraction. Writing in the *Listener*, Quentin Bell thought Frost's work displayed a lack of restraint, and saw a 'perversity in restricting himself to a method which can produce nothing better than pleasant decorations'.[16] The *Times* recognised 'a young painter of wholly abstract subjects who has a well-developed sense of the quality of paint; he is an inventive colourist and designs with some breadth and assurance'. This praise was qualified, however, with the warning that 'it may be felt that abstraction is rather dangerous for an artist who can so readily turn a well-painted picture with all the "quality" in it that pleases the collector … there is an obvious risk of his being content with surface refinements'.[17] In an unsigned review in the *New Statesman* John Berger wrote that in Frost he saw:

> a sensitive and natural talent abused … a sincere painter, a competent draughtsman … and a good designer … [with] a feeling for landscape atmosphere. But, unfortunately, none of this is enough: because his conscious aims never extend beyond the picture frame: because he can't admit that the artist must try to solve problems over and above those simply raised by the mere process of his art; and because he is willing to let everything remain ambiguous – even including his definition of three-dimensional space – so long as his paint-marks themselves acquire a striking actuality … One is reminded of a good shot only shooting duck he himself has released.[18]

The irony was that, while the critics bemoaned Frost's abstraction, the constructionists, a group of artists with whom he was associated, were distrustful of his retention of external references. This group sought to revive and develop the spirit of pre-war constructivism and avowed complete abstraction. As it was dominated by Pasmore, based in Heath's Fitzroy Street house, included Kenneth Martin (also a teacher at Camberwell), and held Nicholson up as an elder model, it was inevitable that Frost should have been drawn into its ranks. The core artists of the ill-defined group also included Robert Adams, Anthony Hill and Mary Martin, and they were joined by other exhibitors such as Nicholson and Hepworth, William Scott, Roger

17
Green, Black and
White Movement
1951
Oil on canvas
109.2 × 85
Tate

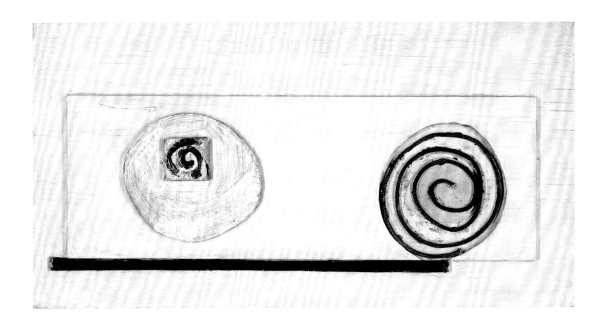

19
Construction
1951–2
Oil and cord on wood
25 × 47.5 × 2
Private collection

Hilton and Eduardo Paolozzi. Though Frost was not included in their first group appearance, in the 1951 London Group exhibition, *Walk Along the Quay* was included in the exhibition *Abstract Paintings, Sculptures, Mobiles*, organised by Adrian Heath at the Artists International Association in June of the same year. After these first appearances, the group was included in several, more diffuse, exhibitions of abstract art, but its major forum was a series of exhibitions staged at Heath's home.[19]

In the first of these, held for three days in March 1952, Frost showed his *Construction* (fig.19). Attached to successive layers of white-painted board are a further circle of board, mounted with a small square on which is painted a spiral, and a piece of yellow-painted card over which a black cord spirals. Despite his work for Hepworth, Frost could not conceive of sculpture in three dimensions and abandoned attempts at carving for construction and collage. Construction offered an extension of collage, enhancing the freedom of abstraction and avoiding the illusionism of painting. One construction (one of the last of this period) went further into the realm of three dimensions (fig.20). In this, three of Frost's characteristic curved forms are mounted at the front of an open box: while one is fixed proud of the facia to create *actual* shallow depth, the other two turn on spindles so that they articulate the space as their coloured faces show on the reflective surface behind. Both the wall-mounted

18 [opposite]
Yellow and Black Movement
(Yellow Painting) 1952
Oil on board
176.5 × 122
Private collection

box and the use of moving elements to define actual space reflect Frost's
knowledge of Gabo's work and related issues.

Frost had been told about Gabo by Berlin, and would no doubt have been
affected by Lanyon's debt to the Russian's work. The association of space
– actual and pictorial – with a socially responsible art was one which
Lanyon had inherited from Gabo and shared with Frost. This was not his
only source of knowledge, however. Not only did Frost have access to the
history and images of pre-war modernist art that Nicholson could offer,
he was also introduced to a wider history by Heath, who was gathering
material for a short history of abstract art, that was eventually published in
1953.[20] There are clear coincidences between Frost's interests and Heath's
artists: his preference for Gris's cubist collages over the work of Picasso
and Braque; Malevich's simple forms; Delaunay's colour; and, in particular,
Kandinsky, who offered a precedent for an abstract art that used colour
as an emotional vehicle and which contained a narrative dimension and
rhythmic brushwork. Frost recalled how, from Heath and Hill, he 'heard
a lot about the Russian Suprematists and Constructivists and Gabo …
Duchamp-Villon, Kupka and Lissitzky. I was very moved by how early on
Kupka was making pure abstract paintings in colour theory in vertical and

20
Construction, Leeds
1954
Oil on metal, wood and board
19 × 26.7 × 9
Private collection

discs [*sic*]. I saw a Lissitzky at the Leicester Galleries that knocked me out, white, black and ochre.'[21]

Frost's later passion for red, black and white compositions can be traced to his admiration of Lissitzky and Malevich.

The aim of Heath's little book was to reassert the social role of abstract art. In his introduction, he lamented the prevalent perception, perhaps stemming from the writings of Wilhelm Worringer and T.E. Hulme, 'that abstract art is either pure decoration, or the work of men who have chosen to retreat within themselves from the world's chaos'.[22] On the contrary, he asserted, 'the pioneers of abstract art were the only artists to adapt themselves to the thought and the rapidly changing social and technical conditions of our world'. While Frost believed in art's social responsibility, by 1953 he had become certain of the necessity to maintain his art's attachment to the real world. One might relate this position to the belief, widely held among his St Ives colleagues and others, in the need for a reacquaintance with the eternal values of nature. Indeed, his *Construction, Leeds* may be seen as a defiant statement as it came at a time when Frost's contribution to the constructionist group was under scrutiny because of his persistent reference to external sources.

In a letter to Pasmore he had to justify his 1952 exhibition of paintings:

> I [am drawn] naturally towards what I call space sculpture and reliefs
> … It seemed so natural after working with paper & thin cardboard that
> one should wish to work in <u>real</u> dimension. Of course right in the middle
> of my work with space construction & relief I was offered the show at
> the Leicester Galleries. Well it was necessary for me to have that show,
> necessary not from a financial point of view but just to pay back some
> of the struggle which has happened over the last few years.[23]

But, he went on, 'working on the reliefs had enabled me to paint or led me to wish to paint more in colour and design which was further freed from a subject … I do see lots of work ahead of me still in paint. This is where you will most probably ultimately disagree with me.'

It would appear that in 1953 Frost wondered whether he would be allowed to show at Fitzroy Street at all. He received reassurance, tempered with some frank criticism, from Kenneth Martin:

I would not say that your works were bad but rather that they were not considered enough or worked on enough. You will say of course that I'm not romantic. But I too have feelings for nature of long and mature standing … With regard to showing at 22 Fitzroy Street … I would doubt whether you would be excluded.[24]

Frost does not seem to have been cowed by this, as his notebooks record his recommitment to paint and to external references:

Construction for me is cutting out the mystery part of art, it is design for fashionable decoration (for the moment) … The pure abstract I must admit I like, but I do not practice it for it does not seem to me to belong to us, but to be a departure from life … and is now fast becoming academic and mannerist by the adoption of various geometrical proportions all too readily at hand in the text book to the complete exclusion of any intuitive feeling.[25]

Frost's defiance was made clear in the group's final exhibition at the Redfern Gallery in January 1955, organised by Heath, and in the accompanying book, *Nine Abstract Artists*, edited by the critic Lawrence Alloway, and published a few months earlier.

Alloway, at that time, advocated total non-figuration and his introduction made his distrust of Frost's work quite clear. While noting a general disregard for theory, Alloway distinguished two groups among the nine artists: the absolute non-figuration of Pasmore, Hill, Adams and the Martins and the 'irrational expression by *malerish* means' of Frost, Roger Hilton and Alan Davie. Writing on Frost specifically, he noted the influence of St Ives, where 'they combine non-figurative theory with the practice of abstraction because the landscape is so nice nobody can quite bring themselves to leave it out of their art'. He went on to object to Frost's desire to communicate emotion through his art:

There are no laws according to which painted forms can be made to transmit emotions. The determining of the outer element by the inner element means, in effect, that anything goes. It is possible to abstract indiscriminately from the contours of static forms, the temporal existence of forms in motion, from forms expressionistically deformed, and so on. In this kind of painting any eccentricity can be justified by reference to the inner element.[26]

21
Blue Movement 1953
Oil on board
109.2 × 122
Vancouver Art Gallery,
Gift of Contemporary
Art Society, London

Frost reasserted his commitment to painting by the inclusion of a series of 'harbour' pictures, including one as early as *Green, Black and White Movement* (fig.17), and a text describing the genesis of a recent work that echoed earlier accounts of such paintings as *Walk Along the Quay*. He described how *Blue Movement* (fig.21) had derived from the movements of boats in a harbour, and from one specific twilit evening, explaining that in it he 'was trying to give expression to the total experience of that particular evening ... an arrangement of form and colour which evokes for me a similar feeling'.[27]

In defiance of Alloway's more dogmatic view, Frost recommitted himself to the aesthetics and practices of St Ives. A reference to the 'space drawing of the mastheads' aligned him with Gabo, and his followers Lanyon and Wells, who found in nature the definition of space through movement that had been explored in the Russian's kinetic and perspex sculptures. Frost stated his intent to communicate in paint his subjective experience before nature. In contrast to an objective non-figuration, he placed subjectivity and the individual's experience of being in the world at the forefront of his artistic project. This was a line which he would pursue with vigour in the following years.

22
**Corsham, Silver and
White** 1953
Oil on canvas
109.1 × 76.1
Royal Bank of Scotland
Group Art Collection

4 THE NEW SUBLIME

THE DETERMINATION OF FROST'S STAND

in the debate with the Fitzroy Street constructionists demonstrates the confidence he had acquired since his uncertainty in Camberwell three or four years earlier. This is hardly surprising because, during that time, his position had become considerably more secure. He was now one of the key painters in St Ives, and a familiar figure among artists in London, enjoying a particularly close friendship with Roger Hilton. Critically, too, his reputation was considerable. In 1951 Gimpel Fils had tried to sign him up, but he continued to show with the Leicester Galleries, where he had one-person exhibitions in 1952, 1956 and 1958. He had shown in a series of important exhibitions in London: in 1951 in two 'Abstract Art' exhibitions, at the AIA and Gimpel Fils; with the Contemporary Art Society at the Tate Gallery in 1952 and 1953; in *The Mirror and the Square* at the New Burlington Galleries in 1952; in Heron's *Space in Colour* at the Redfern Gallery the following year and, again at the Redfern, in *Abstract, Cubist, Formalist, Surrealist* in 1954. In 1951 he had shown in New York in an exhibition of *Danish, British and American Abstract Art*, in 1952 in *British Abstract Art* at the Galerie de France in Paris and, in 1954, he was invited to participate in the Pittsburgh International.

From 1952, Frost also taught at Bath Academy of Art at Corsham Court in Somerset. Corsham has taken on a legendary status in the history of post-war British art. From 1946 it was under the directorship of Clifford Ellis, who supplemented the teaching of the permanent staff with practising artists on occasional short contracts. With William Scott as Head of Painting and Kenneth Armitage as Head of Sculpture, major young artists were attracted there, including several from St Ives. From 1951 Bryan Wynter and Peter Lanyon were employed, sometimes for a few weeks, on other occasions for a term. As well as the stimulus of teaching, Corsham provided a fertile meeting ground for artists away from the professional tensions and domestic obligations of London or St Ives: other teachers included the painters William Brooker, Peter Potworowski and Jack Smith, the sculptor Bernard Meadows, the potter James Tower and the poet James Kirkup.

It has been said that someone was needed to teach life drawing if the students were to get through their exams. In 1952, with his Camberwell background, 'plumb-line Frost', as he became known, was invited to teach these classes. At the same time, he was teaching part time at Willesden Art School in north London. The unpredictable employment policies at Corsham ensured that financial worries persisted, but teaching and increasing sales helped considerably to alleviate them. For example, for the year 1952–3, Frost earned just over £600, of which almost half came from sales of his work and just over a third from Corsham. More importantly, teaching became 'a means of creative discovery, an integral part of painting' for Frost, giving him 'a sense of freedom, of being his own man'.[1] Thus, he achieved a new sense of confidence in himself and in his work.

In July 1954, Frost had just agreed to five weeks at Corsham when he was offered the Gregory Fellowship at Leeds University. He held this prestigious role for two years from October and remained in Leeds until 1957, returning to St Ives each summer. The Gregory Fellowships had been established a few years earlier by Peter Gregory as a means of bringing practising artists into the university. There were fellows in painting, sculpture, poetry and, occasionally, music. They had to do little more than continue with their work. They were not obliged to lecture, though they often did, but had to remain close to the university, working in the studio that was provided. In Leeds, Frost once again found himself at the heart of an exciting artistic group that included not only the other fellows – sculptors Kenneth Armitage and, later, Hubert Dalwood, the poet Jon Silkin, and

Frost's successor Alan Davie – but also university colleagues, in particular from the history and philosophy departments.

Another creative impetus of great importance in Leeds was Harry Thubron, who arrived at Leeds School of Art around that time. Thubron established at Leeds the Basic Design course for all students, which was an introduction to the grammar of visual form based on Bauhaus theory. He was keen to bring in experienced artists and several of the Gregory Fellows, including Frost, contributed to the teaching. Frost also participated in the summer schools that Thubron ran for art teachers and contributed a short essay on colour for *The Developing Process*, an exhibition that gathered the work of teachers and students of Basic Design. The organic principles of growth upon which Basic Design was founded seem to have had an influence on Frost, who spoke increasingly of the way his paintings grew, each mark that he made demanding another in response.

The works Frost produced in Leeds were significantly different from the harbour paintings of the preceding years. Reviewing an exhibition of recent work in February 1956, Patrick Heron wrote that the new paintings 'mark his arrival at a completely personal and extremely inventive style'.[2] The relative scarcity of works from 1955 may suggest, however, that the transition was not easy, and one or two harbour paintings continued into that first year in Leeds. Frost's retrospective accounts of those times attribute the changes in his work to the effects on him of a new landscape. Typically, the sources that he cites are often rather trivial: for example, the linear forms that appear to spin at the foot of the yellow section in *High Yellow, Yorkshire* (fig.23) are supposed to have derived from the sight of sheep's tails blowing in the wind. There is, no doubt, some truth in such tales, but there must be other determining factors we need to consider.

At the end of 1956, after two years in Yorkshire, the artist wrote to a friend:

> Things have changed since Cornwall, for now my starting points are much more difficult for me to think of. In fact I never give them a thought. It's the paint and colour on the surface that is my subject and what I can do with it. I sometimes talk about a subject when I'm pressed for it's so difficult to talk about something which is unknown to yourself and which every time you paint you're trying to find out … There's such a big scale up here and black and white mean so much and when I paint I try to get those sensations through a strong attack on the canvas.[3]

23
High Yellow,
Yorkshire c.1955
Oil on canvas
121.9 × 121.9
Leeds City Art Gallery

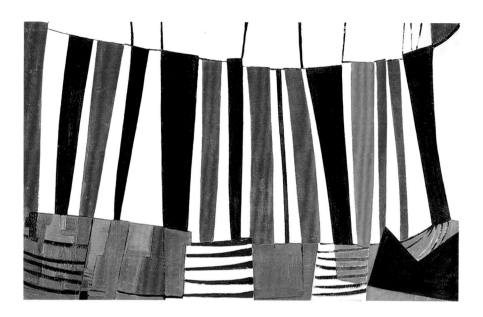

24
Red, Black and White,
Leeds 1955
Oil on board
122 × 182.8
Private collection

He reiterated this point to Lawrence Alloway the following year, suggesting that the change was from a primarily visual experience to one, perhaps, that involved all of the senses:

> I'm not on the same wavelength as I was when in Cornwall. There the visual experience was important, nowadays its practically gone … In those days I was a pretty important guy looking at nature. Now I feel space is a bloody big thing looking at titchy me.[4]

So, the influence of the landscape remained important, not least in suggesting a monumental scale, but, more than ever, Frost's priority was the practice of painting.

Red, Black and White, Leeds (fig.24) embodies the most obvious new characteristics of Frost's work from Yorkshire: a larger scale, a reduced range of colours and a preponderance of strong vertical lines. While the small section of curving lines towards the bottom right-hand corner seems to refer back to the harbour pictures, the composition as a whole is much more simple than the interlocking squares, rectangles and curves of such works as *Blue Movement* (fig.21). It is as if the black lines of *Yellow and Black Movement* (fig.18) have

been condensed and enlarged so that they become the only motif in a dramatic reassertion of the picture plane, as any possibility of figure or ground is erased. Frost later explained where the forms and colours originated:

> During the winter in the North I was always elated, lifted out of myself, the air was keen, visibly sharper, there was a strange silence belonging only to white and snow. There was also an edge of impermanence … a forever of distance in white & when I eventually painted I think I intuitively tried to hold the black & white moment for me and I wedged it for keeps with Red.[5]

As we shall see, black and white were associated with a snowbound landscape. But Frost's account demonstrates how formal concerns led him to introduce red.

He told Claude Rogers that the black verticals derived from the chimneys that interrupted the view of Ilkley Moor that he enjoyed from his flat. However, they have also been associated with the Yorkshire Dales themselves. Close to Leeds, the Dales are a dramatic landscape of clear rivers running through steep green valleys, topped by moorland. The stark linear structures that dominate the Yorkshire paintings are said to have derived from the patterns of black walls that climb and curve over the Dales, subdividing the green hills. Similarly, the scale of the paintings and, perhaps, the greater sense of expansiveness that their size and simplicity make possible derived from Frost's encounter with a new landscape. Typically, and tellingly, he spoke of the place in terms of his own phenomenological experience of it, explaining how he felt diminished in the face of its immensity. In Cornwall, he said:

> one was on a narrow projectory of land … if you stood at the top on one of the moors you saw the sea on three sides … so you were a giant … when I got to Leeds and I went up the Yorkshire Dales I was minute and the dales were huge and the escarpments were fantastic and so I started better to appreciate the flatness of the surface.[6]

There is a neat coincidence here between Frost's appreciation of the flatness of landscape and the desire for shallow space in painting. Thus, he establishes this place as a suitable subject for contemporary art and, perhaps, associates the flatness of his own painting with the source rather than with his own commitment to dominant aesthetic values.

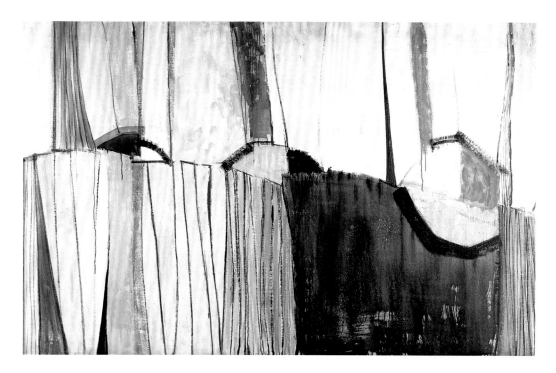

25
Blue Winter
1956
Oil on board
121 × 190.5
British Council Collection

The expansive monumentality of the place was even more evident in the winter of 1955–6, when the snow reduced it to an apparently limitless field of white, patterned by the not-quite-straight lines of the walls:

> Being in a vast cape of white and cold but brilliant space, the sharp air and smooth folds of white snow resting on fields, hanging on black lines … walking was good because I went down and the white came up all around and yet it never touched me, so I was a black thing in a funnel of white with no space that I knew. I could not touch the sides, the space and silence went with me as I walked, and I was so small.[7]

The suggestion of both attraction to, and a fear of, an awesome nature is typical of a sense of the Sublime. Frost's description of his experience of inferiority within nature, 'with no space that I knew', is consistent with the interpretation of the Sublime as that before which one's own identity is threatened.

It was with the Leeds paintings that Frost developed his use of narrative to explain his work, having been reassured by an introduction to the philosopher Karl Popper's theory of subjectivism soon after his arrival. Each picture is linked to a description of an event, perhaps humorous, even flip;

but often the story tells of a moment of enlightenment, what the artist has described as 'moments of truth. Moments when everything seems clear and one is transported out of the normal. Somehow one is more aware, able to see.'[8] For instance, Frost described how *Winter 1956, Yorkshire* (fig.26)

> came from the fact of being in a strong cold black and white environment. A day out with Kenneth Armitage & Rosalie Blackburn. The challenge of a toboggan ride. Hill 60 Roundhay Park Leeds. Big audience, Rosalie very brave & prepared to take the sledge from the top of Hill 60. Great speed Black Russian fur hat roaring down to the bottom. Black figures, strong white & speedy flurry. I went from half way, lost the sledge at the dip (concave form) (shallow curve) & sailed right on without the sledge slid along on my chest straight into the spectators, bowled several over. Back home 8 × 4 hard board & the continued excitement of Black & White led me to paint Winter 56. To take a line from top to bottom & keep it alive was a real challenge … Tone did not interest me, colour did, colour & line, though Black & white were my passion at that time.[9]

Here is a good example of the artist's use of a jolly story to obscure more serious aspects of a painting. With a series of continuous, irregular black lines, interspersed with brighter colours and contrasted with the solid form of the black square in the top left-hand corner, Frost succeeded in creating a sense of vertiginous descent. More than ever before, he captured a sense of movement in actual space within the confines of two dimensions.

Anecdotal explanations did not simply apply to a single work. For example, while a particularly evocative description attaches itself to *Red, Black and White* (fig.27), this was only the first of many works to feature the device of the pentagon:

> I drove through the snow and had lunch with Herbert Read … After lunch we went for a walk … I looked up and I saw the white sun spinning on top of a copse … now I recall that I thought I saw a Naples yellow blinding circle spinning on top of black verticals. The sensation was true. I was spellbound and, of course, when I tried to look again 'it' had gone, just a sun and a copse on the brow of a hill covered in snow … I didn't just come back and paint the picture … I always have to absorb the moments and then let them go … Sometimes I go for a couple of years before I can get clean as it were and discover the moment again in paint.[10]

26
Winter 1956, Yorkshire
1956
Oil on board
246.7 × 125
Tate

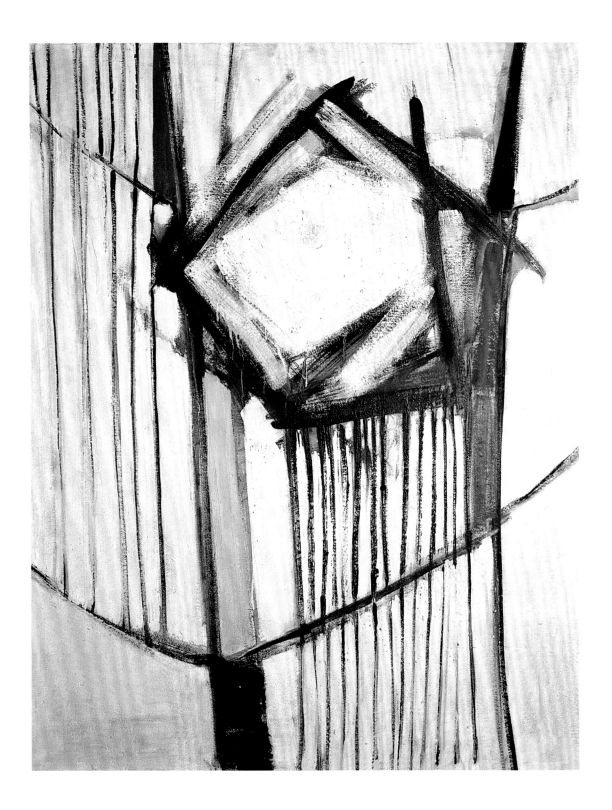

The process of formal development can be seen in the artist's sketchbooks, where 'doodles', as he called them, often reveal the original motif while providing the formal idea that will be developed through gouaches and collages to become the basis of a painting.

The polygon provided Frost with a device that gave structure to his compositions, and which could suggest depth – in that it appeared to open onto a space beyond – or could emphasise the picture surface when it was filled in or traversed by other marks. He employed it for several years, during which time it was used in works which were tightly structured, as the harbour paintings had been, and in others which were dominated by his loose, liquid use of paint. The device was praised by Heron, who used it to demonstrate how Frost outshone run-of-the-mill tachiste painters. He noted that 'In Frost's new work an overtly geometric (and somehow symbolic) form lies involved in the downward-moving rain of pigment gestures', that retained the excitement of the ambiguous 'spatial meaning' of tachisme, while adding:

> a broad compositional structural statement lying *behind* the bead-curtain of dribbles, that gives the picture that power and punch, that three-dimensional focus and concentration of space that no purely Tachist picture ever exhibits.[11]

As Heron's critique demonstrates, various qualities which Frost had developed in his work in Leeds aligned him with recent developments in Europe and America. Though he had produced big paintings for several years, in 1956 the larger scale of his work could not help but be associated with the first British showing of American abstract expressionism at the Tate Gallery in London, in January that year. Like his colleagues, Frost would certainly have been aware of the work of Jackson Pollock, Willem de Kooning, Clyfford Still, Franz Kline and others through magazines and personal accounts – William Scott had met many of these artists during a visit to New York in 1953 and described their work to his friends in Britain – and would have seen one large Pollock at the Institute of Contemporary Arts (ICA) in the same year.

27
Red, Black and White
1956
Oil on board
122 × 94
Private collection

According to Heron, writing at the time, it was 'the size, energy, originality, economy and inventive daring' of the American works that impressed most.[12] Frost, however, had produced a ten-foot painting as early as 1953 (fig.11), as a relative in the timber business provided him with unusually large boards.

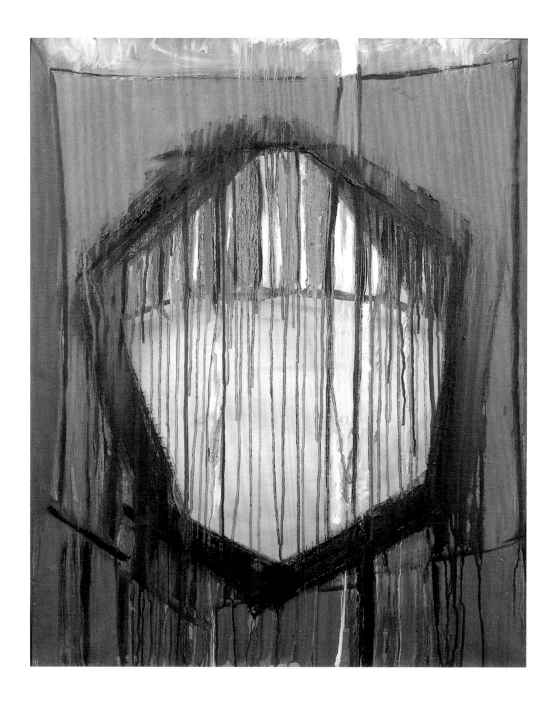

28
Khaki and Lemon
1956

Oil on canvas
76.2 × 63.5
Tate

29
Terry Frost in his St
Ives studio c.1957

Similarly, it is notable that few of the paintings shown at the Tate were over five foot and only Pollock's *Number One* 1948 was larger than *Winter 1956, Yorkshire.* As Heron's comments may suggest, the reduction of Frost's palette invites an obvious comparison with the work of Kline, whose work in the exhibition – *Chief* 1950 – consisted of swirling, gestural, calligraphic black marks on a white ground, or with the more static forms of Robert Motherwell's *Granada* 1949.[13] There were, however, more obvious recent precedents for painterly, monochromatic canvases: specifically, smaller works produced by Hilton and Scott around 1953–4. In particular, Scott had made several paintings in which a white ground is traversed by a few horizontal and vertical lines, and the whole composition is anchored by a black square that anticipates the similar device in Frost's work.

More important than the possible influence of American painting was the proximity of Frost's work to painting practice in France. Heron noted in the Americans' art an 'absence of relish in the *matière* as an end in itself, an absence of worked-up paint quality such as one never misses in the French'.[14] This was a quality which had long been important to Frost. As early as his Camberwell abstract, *Madrigal,* he had shown an appreciation of the value of an expressive paint surface. As Heron, again, noted, his harbour paintings displayed

an extremely subtle feeling for surface, for a sort of dry opulence of
touch, which conferred great sensuosity and a richness of texture
and color upon what might otherwise have remained an austerely
architectural configuration.[15]

So, Frost's appreciation of an expressive paint surface was already seen to be
in line with recent French practice. He would have had plenty of opportunity
to acquaint himself with French *tachisme*, examples of which were frequently
shown in Britain. The linearity of Frost's work could be compared to the
structured abstraction of such artists as Roger Bissière and Alfred Manessier,
both of whom had exercised a considerable influence on Hilton in the past.
Indeed, in at least one work the rocking boat forms of the *Movement* series
were reduced to a simple pattern of straight and curved lines reminiscent of
Hilton's most Francophilic work.

As well as the first sight of the American painting, 1956 was also the year in
which Frost made the first of many visits to Paris in the company of Hilton.
There they visited Pierre Soulages, whose austere, but succulent, abstracts of
broad strokes of bitumen-black paint had secured his position in Britain as one
of the best known of the younger Parisian painters. They also met Sam Francis,
an American in Paris, whose lyrical abstractions, derived from natural sources
and made up of discrete dabs of paint which were allowed to drip down the
canvas, had been shown in London in 1953. Francis was hugely admired by
British artists, and Frost's use of dribbling paint in such works as *Orange,
Yellow and Black Painting* (fig.30) might be associated with their meeting.

In 1958, Francis was the central figure in a touring exhibition entitled
Abstract Impressionism that identified a group of contemporary abstract
artists whose work displayed a disposition for an all-over, informal aesthetic,
and could be related to the natural environment. Though Frost was not
included in this gathering, one can see a similar concern in his work, both
formally, in terms of the dribbling paint, and in his interest in the landscape,
or in nature, as a source and as a symbol of the individual's existential state.
It was certainly during this period that his work was, technically, loosest,
and the association of his art with the enormity of nature reveals one of his
key concerns and suggests a more useful comparison with other artists than
mere formalism will allow. The analysis of Abstract Expressionism in terms
purely of form, associated with Clement Greenberg and reiterated in Britain
by Heron, has long been augmented by studies of the concerns which

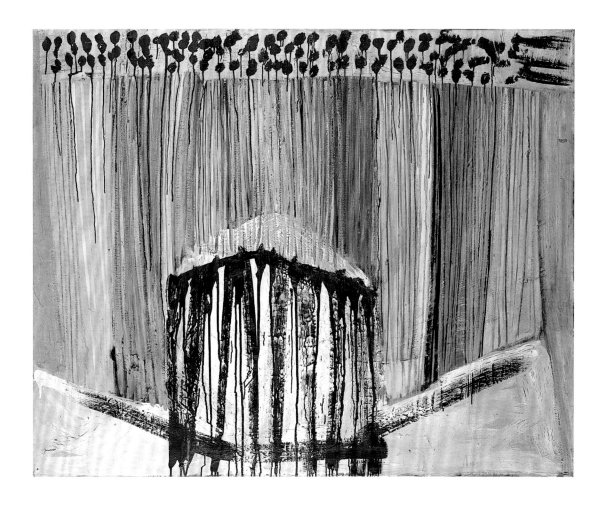

30
Orange, Yellow and
Black Painting
c.1956
Oil on canvas
101.5 × 127
Private collection

informed the work of the individual artists. Two themes seem to have had a bearing on Frost's work: myth and the Sublime.

The search for a new mythology was a recurring theme in post-war culture, as artists and writers sought to fill the gap left first by the loss of traditional myths and religion in the wake of modernism, and then by the loss of modernism's own ambitions. In Britain, Europe and America, artists showed an interest in a variety of unconventional forms of spirituality, most obviously Zen Buddhism, and mystical texts; they rediscovered Sir James Frazer's comparison of world myths, *The Golden Bough* (1922); and Carl Jung's 'analytical psychology', with its communal and cultural dimension, was ascendant over the individualism of Sigmund Freud. Closer to home, Lanyon spoke of his return from the war as the discovery of his own myth in his homeland of Cornwall. In a similar way, Frost described his anecdotal explication of his art as the definition of a personal myth:

> you make your myth and paint it. My memory is what I rely upon, from that moment of discovery when I happen to be made aware, or aroused by, something which I've discovered in nature ... that becomes my time and space and by the time I use it it's my myth that I'm working on What I don't really know, of course, which I can't really explain is how I get from the story, the memory, to what I actually make which doesn't necessarily say to other people what that idea was.[16]

It is typical of the time that the individual experience, the personal myth, comes to stand for, or aspire to, a more general condition. The rise of the individual over the crowd of modernity, and the re-engagement with nature, were recurrent themes in the literature of the period that tackled the problem of what was frequently termed 'the condition of man'.

Frost's description of his experience of the snow-bound Yorkshire Dales conjures up images of Romantic paintings, such as Richard Wilson's depictions of Welsh mountains, in which tiny figures contemplate the awesome grandeur of the natural world. These are classic representations of the Sublime, the aesthetic thrill resulting from one's experience of fear before a phenomenon so enormous that one's identity is threatened. This artistic trope was undergoing a revival in the work of American artists, such as Mark Rothko and Barnett Newman, whose expansive canvases were compared to the Romantics' representations of the Sublime; in particular, a comparison

was made between a viewer standing in front of their works and Caspar David Friedrich's *Monk by the Sea* 1809 – a depiction of man contemplating infinity and his own existence.[17] Such images are not simply about nature, but are statements about the individual's place in the world, articulations of an awareness of one's minuscule scale and vulnerability.

Frost's awareness of this aspect of his work is reflected in his statement: 'For me the problem has been to put down on a flat surface the experiences of being in this life.'[18] This need not be denoted by the size of the work, though a painting's ability to envelop the viewer was one way of achieving the effect. *Leeds Painting* (fig.31) is one of several works of this type, in which strong colours are framed by, or provide a background to, a black rhomboid. The technique is typical of the time: the works are heavily painted on rough sacking, and are caught in a tension between a tightly controlled structure and the informal fusion of different oranges and yellows. For Frost, this tension was closely linked to his desire to communicate his original experience. It achieves a spatial ambiguity in the painting, as the framing device seems to create depth which is blocked off by other black marks and the insistent flatness of the different hot colours. He explained at the time how the style and technique were crucial to his desire to express his own experience of nature as an articulation of his being in the world:

> Today I am interested in relating form and colour to create a pictorial space which is as powerful as actual space sensation. Not the single-viewpoint space of perspective, or a multi-focal space, but a free space, the space we move about in, localized space. I consider the discipline of structure of first importance, but the making of this space is equally dependent on the freedom and vitality of the painter's action intuitively controlled. In this way, I combine a sense of disciplined growth with the free discoveries made in the actual process of painting.
>
> For me the central problem today is the contrasting of freedom and discipline to achieve a final equilibrium.[19]

The contrast of freedom and discipline, instinctive painting and compositional control, reflected a long-running debate that Frost had been having with Hilton about abstraction and figuration.

Frost first met Hilton in 1951 and they remained close friends until the latter's death in 1975. More importantly, they were each other's

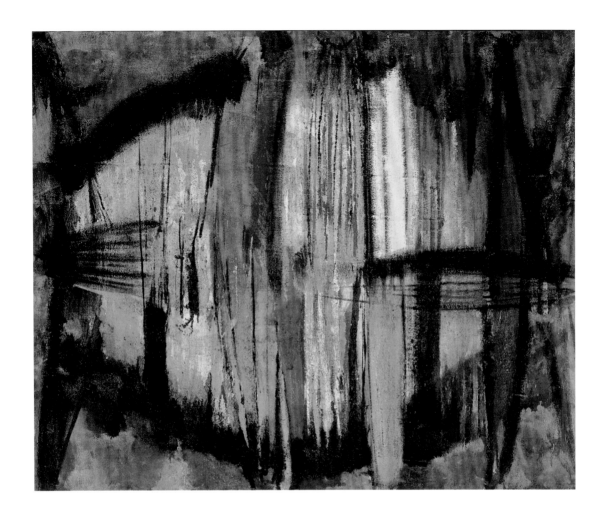

31
Leeds Painting
1954–6
Oil on canvas
167.6 × 182.9
Private collection

main critics and supporters, with Hilton's intellectual background and experience of Paris providing a counterweight to the freshness of Frost's untutored approach. In the changes that Frost's work underwent during the 1950s, one can see the increasing effect of his correspondence with Hilton. For example, in contrast with Pasmore and the constructionists' use of the Golden Section, Frost recalled being 'shot down' by Hilton for mentioning 'composition'. Frost explained: 'You don't compose – you put things where you want to and you have to take a gamble, to do something for *now* which is highly dangerous.'[20] While Frost was in Leeds, Hilton attempted a return to figuration, believing that it was time to move on from a dogmatic approach to allow for both figuration and abstraction, but to reaffirm the pertinence of painting as opposed to construction. 'Don't worry any more about architecture or construction,' he advised:

> For myself I have decided that it is all nonsense. The adventure of painting is far from finished. Painting must be given back its soul. In this aspect your painting is an object lesson to all of us … you are one of the few living and vital forces in painting in England today.[21]

So, Hilton proposed to introduce a more human element to his works, while retaining their abstract qualities, to escape what he described as 'this tiresome dichotomy' of figuration and abstraction.

The extent to which his change of heart reflected Frost's own feelings is hard to judge. Frost seemed to look back approvingly at the move away from construction, contrasting the two dominant strains in British art of the time: 'an … expressionist type of painting which immediately became tonal and fluctuated a space to equal its feeling … [and] the tight boys who were flogging the golden section to death' – from which he distinguished Hilton's attempt 'for a free space through colour and an opposite to normal composition'.[22] The years in Leeds had witnessed a widening of the distance between Frost's original source and the appearance of his painting, and his work would continue to develop towards a greater degree of abstraction. However, one might say that, in his approach to the landscape and his attempt to communicate his experience of it in paint, the human dimension in the work was actually enhanced. It was in this period that he really developed the idea of 'moments of truth' providing the inspiration for paintings, and it is no coincidence that the work of that time was especially concerned with the individual's position in the world.

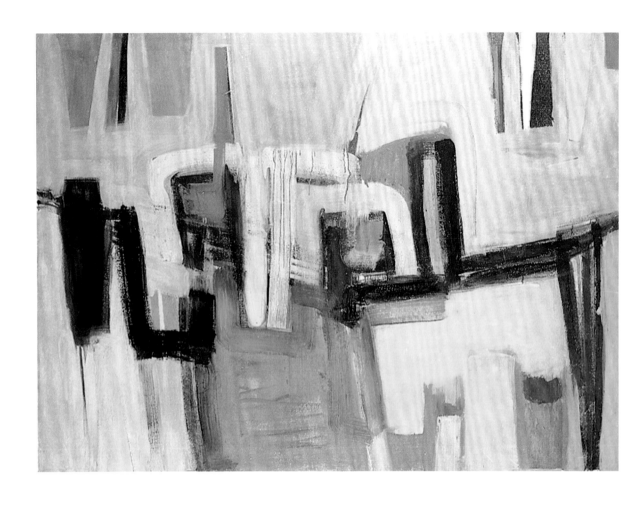

32
Yellow Painting
1957–8
Oil on board
160 × 213.4
Private collection

5 COLOUR AND FORM

FROST LEFT LEEDS and returned to St Ives in the summer of 1957. He continued to produce the polygonal works which Heron would praise so enthusiastically in October. However, the paintings which made up his third and final one-person exhibition at the Leicester Galleries a year later were of a different nature. *Yellow Painting* (fig.32) was one of the larger works in the show. It shows a more all-over composition, a series of large, calligraphic forms reaching to the edges, with other, smaller elements seeming to enter from the top and bottom of the picture. Though in places the paint was still allowed to dribble, and despite the structural aspect of some of the more dominant forms, the overall effect is at once less disciplined and less fluid than the polygonal works. There is a feeling of fragmentation, or of compilation, as if the paintings were made up of a collection of disparate elements. Some are dominated by a single area of colour surrounded by smaller forms, others combine clusters of lines and sundry other forms in compositions which avoid a single focal point.

Heron and Greenberg had debated the importance of the edges of paintings: Greenberg advocated centrally focused compositions in contrast to the British preference for reaching to the sides. Perhaps, Frost's new style signalled his adherence to the doctrine of the edge. If this is so, then the

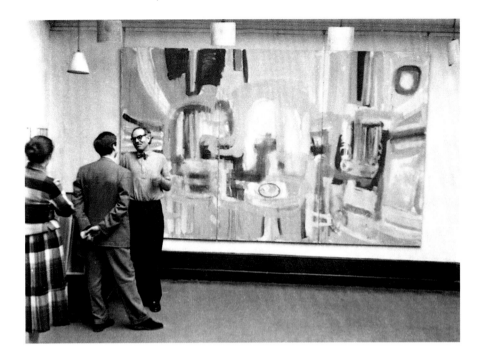

evolution of one of these works may reveal a significant change of heart. One wall of the 1958 exhibition was taken up by a triptych (fig.33), which was made up of broad bands and strokes of colour, similar to those of *Yellow Painting*. These gave it a dynamism as the forms seemed to reach to, and sweep in from, the edges of the painting. Over the next year, however, Frost almost entirely reworked the painting. Having tried different colours – he painted over much of it with white and blue – he finally covered most of the busy, expansive composition with a lemon yellow (fig.34). The result was that some of the clusters of lines, which had previously intermeshed with other forms, came to look more like three central icons. In the reworking of this one, large work, Frost abandoned compositions that fill the picture for a style in which small conglomerations of lines float like islands within a sea of colour. This sometimes resulted in works of extraordinary economy of form and colour. Around that time, this could be related to the work of Hilton, who was making paintings of simple forms and few colours, sometimes merely white on white, as well as to that of Rothko and Newman.

Despite the fact that this was a successful period, Frost was still unsettled. Following the 1958 exhibition, he had signed up with the new Waddington

33

Terry Frost exhibition, Leicester Galleries 1958

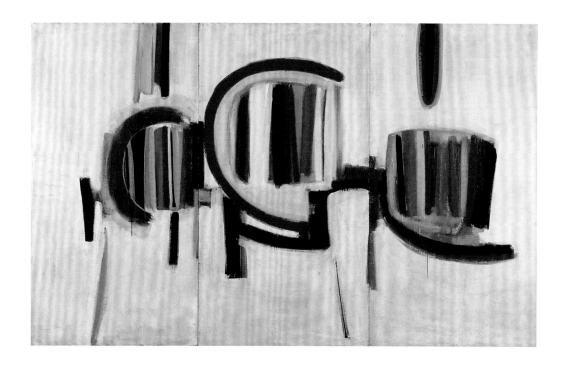

34
Yellow Triptych
1957–9
Oil on board
228.5 × 365.8
Tate

Galleries. Unlike most other dealers, Victor Waddington paid a regular stipend and, in May 1959, he brought Frost together with Hilton, Heron and Wynter to form the 'Middle Generation'. Frost felt uneasy about this arrangement because, though fond of all of the others, he felt that Heron's and Wynter's work was considerably inferior to his own and Hilton's, with which he was glad to compete. Meanwhile, his international profile was enhanced, as he had his first New York show at the Bertha Schaeffer Gallery in November 1960. Nevertheless, he wrote that year to say that his work had become confused, 'due to my selling paintings regularly for twelve months … it's very worrying. Not half as nice as worrying about not selling them.'[1]

The changes made to *Yellow Triptych* may reflect this state of confusion. It was around 1960, however, that the artist seemed to enter into a phase of particularly distinctive work. *Force 8* (fig.35) shows a new device in Frost's repertoire of forms: the V-shaped wedge. Here it floats within a field of colour, along with a line-cluster, another thin linear form and a part-circle. The wedge introduces a certain dynamism and tension to the composition, its acute angle creating a sense of downward movement, while its spreading arms seem to open the picture with their outward pressure. This was in keeping with the artist's description of the painting's origin:

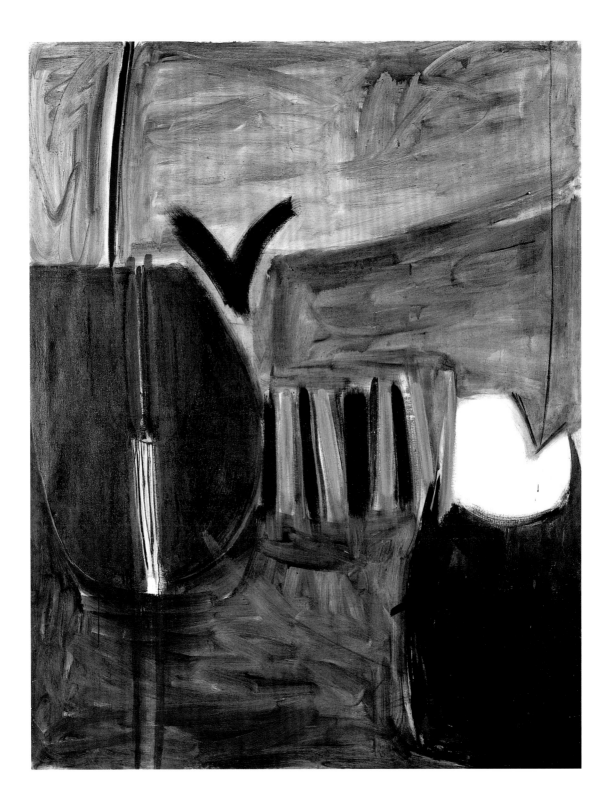

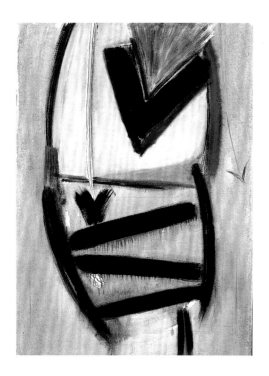

The title came because as I walked to the studio I had to lean against a gale and when I got in and started work on the painting the radio said Force 8 gale and I realised that was the title I needed for the painting I was working on. The rhythm and expressionist type of paint had a relationship with the kind of gale pressure I had just experienced and could now hear bashing against my studio window.[2]

The use of the wedge to tighten a composition is even more apparent in a number of works in which it appears at the end of a long, usually thin, line so that it becomes an arrow-head (figs.1, 36). At the same time, this motif reveals Frost's increasing use of ambiguity in form and content, for while serving these compositional functions, the wedge also became a symbol for the female nude. In numerous works it, and other closely related motifs, 'enter', or open up, a larger form in a way that the artist has identified as an allusion to penetration and the sex act (figs.37, 38).

Interestingly, the sculptor Hubert Dalwood, to whom Frost was close in Leeds, had employed a sort of bifurcated 'V' to denote female genitalia, which Hilton had also used in his painting *The Aral Sea* 1958. At a time when the line between abstraction and figuration was increasingly under question, such allusive forms and symbols became common. In a way

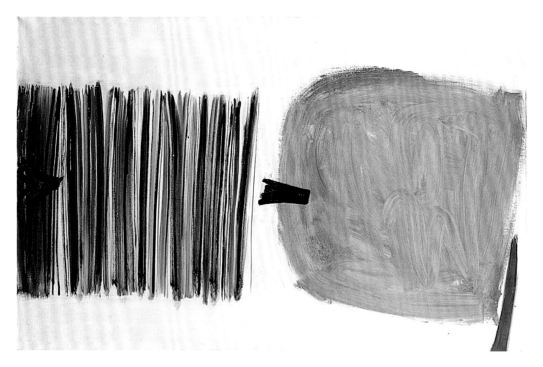

akin to poetic imagery, they allowed the artist to suggest a range of ideas
without committing to a single message or subject.

The ascendancy of the wedge also reflected the increasingly frequent
occurrence in Frost's work of the female nude. The theme of the Three
Graces, or three nude figures, had fascinated the artist since he first
encountered it in Rubens's *Judgement of Paris* 1635–6 in the National
Gallery. The combination of the interaction of the three figures – or the
same figure seen from three different viewpoints – and the erotic overtones
of the subject made the source of much interest. He had addressed the
theme some years earlier, but his 1960 version (fig.38) possessed a new
erotic charge. While the individual identities of the three figures is unclear,
the composition is dominated by the penetration of the wedge. While
collage had remained a part of Frost's repertoire, this work reflects its
increasing prominence, as the area of bare canvas on the right-hand side
of the picture was glued on over the painted ground.

For Frost, the theme of the Three Graces was allied to his interest in the
pagan gods of Cornwall, specifically the idea of a sensuous figure of love.
He made several works which referred to Gwennor, goddess of love, who

37
Black Wedge
1959
Oil on canvas
104.1 × 154.9
Private collection

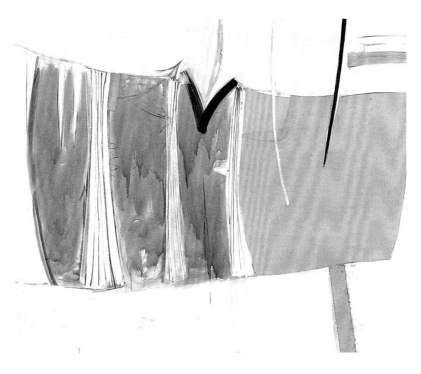

38
Three Graces
1960
Oil and collage on canvas
198 × 243.8
Bristol City Museum
and Art Gallery

emerges from the sea and drowns unwary fishermen in love. The theme of woman as both attractive and threatening was, of course, a well-established representation. The nude was a particularly popular theme in the early 1960s, for, while it had remained a staple for traditional artists and art schools, it was also taken up by abstract painters, including Lanyon and Hilton. This may be a reflection of the increasingly liberal attitude to sex and nudity that emerged in the first years of the 1960s, marked by such key moments as the trial of D.H. Lawrence's *Lady Chatterley's Lover* in 1960. In the visual arts, the new social values were most clearly signalled in the work of Pop artists, who appropriated images of public figures such as Marilyn Monroe and flirted with the boundaries of pornography. One can see the emergence of this theme in the work of Frost and his friends as an indication of their move away from the romanticism of the Cornish landscape towards Pop's more contemporary themes. While Frost recognised the subconscious influence of Henry Moore's reclining figures on his nudes, it is more significant that the bikini is one source that has been suggested for his V-shaped wedge.

The ambiguity of Frost's forms was well demonstrated at this time in a series of pictures which were dominated by two quadrants. In these, his boat forms, the erotic nude, and purely formal issues hold equal sway. The title

39
SS9
1962–3
Oil and collage on canvas
152.5 × 101.5
Private collection

40
Figure, River Nidd
1955
Oil on paper
76.2 × 55.9
Private collection

of *SS9* (fig.39), and the lettering from which it takes its name, suggest a boat, or boats, to be the main motif. Frost's account, however, describes a different origin, whilst acknowledging the ambiguities of the forms.

> I made a drawing of Kath from behind [fig.40] … and there were these two semicircles of her buttocks coming in from the side of the paper with the crisscross of the lacing of her bathing suit, tied in a bow … and that simple drawing had a lot of meanings for me. I remember as a kid I used to have to lace up my grandmother in the ivory coloured stays … And I remembered how Ben used to talk about 'tightening up the form' as though he was talking about a spanner. And then when I looked at those semicircular shapes in the drawing my mind went back to the boats, and I thought about how the brown mizzen sails at the stern are laced taut.[3]

So, the theme combined the female body – as both sexual and maternal – and memories of boats as well as recollections of childhood. The uniting element is the tightened form. Frost produced a number of works in which the dynamic of the composition comes from the tension between the two curved forms in close proximity. A carefully-tuned harmony of two forms in tension had been an established theme in the work of Scott and Hilton. Frost then introduced charcoal lines criss-crossing between the two quarter-circles. With *SS9* he employed actual bootlaces, threaded through holes punched in the canvas, which appeared to draw the two forms together. When he took the first one to London, he recalls Leslie Waddington saying 'it's too sexy, it's like a chastity belt'.[4] A series of paintings, collages and prints involving lacing ensued. Again, this group demonstrated the re-establishment of Frost's use of collage that would persist for the rest of his career. While this would normally consist of canvas stuck to canvas, in the 1980s he produced more complex works in which forms were literally suspended from the support (fig.57).

These were years of change and consolidation, a time that he would recall as 'a period of total confidence … any mark I made seemed to be fine'.[5] In London, he was now showing regularly with the Waddington Galleries, where he had seven one-person exhibitions between 1961 and 1978. In 1960, when he travelled to New York for his first exhibition at Bertha Schaeffer's, he was welcomed by such artists as de Kooning, Newman, Motherwell, Rothko and Kline, several of whom invited him to their studios. Two years later, in 1962, Schaeffer staged his second exhibition. In 1963 he showed in Zurich, and the following year a retrospective exhibition travelled to several

British venues. In the summer of 1964 an exhibition toured California to coincide with Frost's time as Visiting Professor at the University of California, San José. By that time, the Frosts had moved house. St Ives, he felt, had lost some of its vitality: Nicholson had left in 1958 and Lanyon was talking of going to live in America, where he was spending an increasing amount of his time. At the same time, Frost felt that the forces in the London art scene who disliked 'St Ives' were gaining ground and that he needed to be nearer the capital. In 1961 he tried to buy a house in London, but could neither borrow sufficient money from a bank nor get an advance from Waddington's. So, in 1962 he decided to move back to the Midlands and, early the following year, the family moved into a large house in Old Parr Road, Banbury. Initially, Frost taught part-time at Coventry Art College, then at Reading University. In 1965, he went full time, rising to professor before his retirement in 1974, at which he time he became a visiting professor until 1981.

Inevitably, with a new environment he found new motifs for his painting and the work changed. As he has explained, the primary source close to Banbury was the Tudor house at Compton Wynyates, where he visited

> the marvellous little chapel in which I found the flags that were used
> … in the Battle of Edgehill which had the best chevron I've ever seen
> … that moment standing in that chapel and me with that chevron and
> those blue olives all round it was a moment which I've treasured and
> I've used … I'd probably used that chevron before then, but to see it
> in actual fact when I was alone was very important.[6]

The well-used chevron, which he might have seen in New York differently employed by Kenneth Noland, did become a major feature of his work, appearing often within a circle, which the artist recognised as a signifier of a nude 'because that's penetration'.[7] Such forms were increasingly isolated, deployed with a degree of regularity across the field of a work as if the conglomerations of lines, areas of colour and other forms which had jostled rather awkwardly in the paintings in the 1958 exhibition had been condensed, and isolated, into a series of circles. However, there were other sources. Banbury introduced a new urban dimension to Frost's art, as he began to draw the fronts of lorries, which had always interested him, as well as road signs. He would photograph the signs that were proliferating on the roads, not least on the new developments of Banbury and, though they irritated him, it is clear that they also provided a certain carnivalesque pleasure. The divided circles in his

41
Red, Blue and White
1966
Oil on canvas
218.4 × 172.7
Private collection

paintings have also been related to the speedometer of a car travelling along the burgeoning road systems of modern Britain, the diagonal lines defining its speed.

One might therefore say that Frost's use of signs had undergone a reversal: whereas before he had abstracted a form from an external source and elevated it to the level of a sign, he was now using pre-existing signs and reducing them to abstract forms. The resulting works, such as *Red, Blue and White* (fig.41), show an iconic quality that was echoed in other areas of contemporary visual culture. The vertical bands of circles are arranged above the two quadrants of such works as *SS9* to create an overall composition that recalls a military decoration. If that suggestion is fortuitous, the red, white and blue colouring and emblematic quality of the image can be related to youth culture's recuperation of the badges of nation and the establishment during the 1960s, most famously illustrated by the Beatles' donning of archaic military garb for the cover of their *Sgt. Pepper* album in 1967. The change in style seems to show Frost wishing to signal his delight in all sorts of visual stimuli, not only such romantic sources as the landscape. It also marks a move towards a greater commitment to a decorative abstraction, completely detached from any specific literal meaning.

This was reflected in his impassioned exchange with Hilton, who suggested that the 'moral' issues of painting now outweighed the technical ones. 'The mechanism of painting has to be harnessed to some idea,' he wrote:

> You have to be in other words representing something. Now we can expose a totally blank canvas & hardly an eyebrow will be raised. You can't go further than that. So we have to start again & paint something ... Some time there must be a meaning or a message.[8]

Frost's hostility to painting with a message was clear:

> your message idea is phoney to me, and not moral ... Please define message, religion; figuration I understand, abstract I understand. And I think I can recognise and sense a work that has what today I will call 'magic', and demands reverence, respect, worship, and me to raise my hat and to bow. What the hell has this got to do with message? Write a book, or take a dog collar, but don't paint.[9]

So, through the rest of the 1960s and into the 1970s, Frost produced a body of work which was remarkable for the formal simplicity and openness of the

42
June, Red and Black
1965
Acrylic on canvas
244.5 × 183.5
Tate

paintings. In both of these qualities, he was helped by a new medium, as he began to paint, primarily, with acrylics. Acrylic artists' paints had emerged in America during the 1950s, and gained prominence at the beginning of the 1960s, as their physical qualities suited the desire for the large, flat areas of unmodulated colour of Post-Painterly Abstraction. Acrylic emulsions were produced in Britain from 1963, but Frost did not encounter them until they were supplied to him at San José. Unlike oil, acrylics are quick-drying, so one painting can be worked on at a time, and they can be thinned without losing the intensity of the pigment; thus a strongly coloured, but thinly painted, surface can be achieved. These qualities complemented the new 'heraldic' character that Frost had identified in his recent work.

Though he would occasionally revert to oil, Frost embraced the new paints with enthusiasm and produced a large number of pictures which were characterised by strong, unmodulated colour arranged in a variety of forms. In contrast to the delicately expressive surfaces of his earlier work, and the combination of different qualities of paint – thick and thin, dabbed and dripped – Frost's work came to ride simply on colour and on the shapes that contained it. One of the first of this type was a series of paintings made up of red and black quadrants on a white field (fig.42). Though these were clearly a development from the laced boat/body works of 1962–3, the simple flat forms also recalled the art of Ellsworth Kelly that Frost had seen in New York in 1960. While the tension of simple forms brought into close conjunction had become even more important, Frost acknowledged a possible anthropomorphic reading when he nicknamed these works 'Mae West', referring to the buxom film star.

The sparing arrangement of these suggestive shapes on a large canvas continued. In *Red, Black and White* (fig.2) two curved, breast-like forms are held in tension as the narrow strip of white between them becomes the most active part of the composition. With such works, Frost reached new heights of abstraction, as the shapes are stripped of much of their allusive meaning and reduced to large areas of pure colour that enwrap and absorb the viewer. Conversely, from the Mae West paintings, Frost developed a series of works in which the ground became the active element, so that what had been merely the space between the forms was now a curvaceous cross. In *Spring* (fig.43), the tapering arms of the cross reach outward to the edges of the composition, with a variety of other forms – chevrons, a collection of sinewy lines, and a rectangle like an inset picture – activating the periphery and space of the picture.

43
Spring
1966
Acrylic on canvas
221 × 172.7
Collection of the
artist's estate

If these works were primarily concerned with the distribution of discrete forms within a space, others of the period also rested upon the shapes themselves. *Red and Three Blues* (fig.44), for example, relies for its effect on the soft appearance of its forms, which seem to tumble down and bulge outwards, as if straining the edges of the canvas. Using the most simple of colours, Frost seems to play with the viewer by disturbing the stasis that one would expect in a picture made up of three shapes, with the implication of an internal dynamism. The creation of an illusory massiveness to the forms was yet more apparent in a series of *Suspended Forms* paintings (fig.46), in which a sense of gravity is conjured up by the shape of the different areas of colour. These became increasingly literal, as he made collages on the same theme and then produced a group of brightly painted, stuffed, canvas tubes which literally responded to gravitational forces.

Over the years, from the 1960s and through the 1970s, Frost employed a variety of compositional themes: various means of creating a sense of movement within the static confines of the canvas. Certain groups of

44
Red and Three Blues
1970–1
Acrylic on canvas
213.4 × 182.9
Private collection

45 [opposite]
Summer Collage
1976
Acrylic and paper
collage on canvas
215.9 × 165.1 cm
Collection of the
artist's estate

46
Suspended Forms
1967
Acrylic on canvas
182.9 × 132.1
Collection of the
artist's estate

47
Yellow (Moonship)
1974
Acrylic on canvas
215.9 × 241.3
Collection of the
artist's estate

works, their titles suggested, had some relationship to external sites or events, such as a group of paintings with forms tilting to one side, which he associated with a visit to Pisa, or another in which a host of brightly coloured shapes follow a slightly curved vertical, which were apparently inspired by the moonshots of the early 1970s (fig.47). Whatever the apparent source or reference, all of these works really used shapes as vehicles for colour, as Frost explored the possibilities of intense hues and their relationship to form. Later in the decade, he returned to more geometrical arrangements in which the bright, discordant colours became the dynamic elements in a stable structure (fig.45).

During the 1960s and 1970s, Frost's brash colouring echoed aspects of popular culture, while, at the same time, his persistent commitment to painting distanced him from the mainstream avant-garde. The 1960s, with the advent of minimalism, Fluxus and conceptual art, had seen performance and text rise to dominance over traditional media and practices, in a reaction to the high-art values of abstract painting and sculpture. The continued production of an art predicated on the theories and values of 1950s painting ensured Frost's relative marginalisation, until a recovery in the 1980s, following the revival of painting.

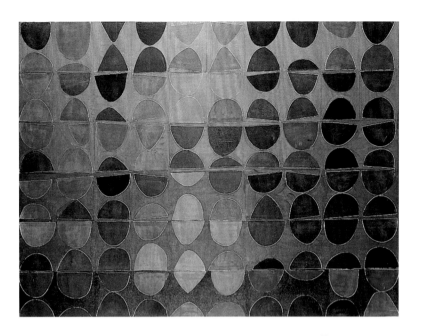

48
Through Blacks
1969
Acrylic and collage
on canvas
198 × 259
Tate

49
Through Whites
1981
Oil and acrylic on canvas
122 × 122
Collection of the
artist's estate

6 'MOMENTS OF TRUTH'

COLOUR HAD BEEN one of Frost's major concerns since the beginning of his career. At Camberwell, he had read Michel Eugène Chevreul's *Principles of Harmony and Contrast in Colour* (1854), which defined a theory of colour interaction. So, from the start, Frost was mindful of the role and effects of harmony, contrast and discord, and continued to use those ideas to the end. In the 1950s, one of the doubts he had about constructivism was artists' failure to recognise that form and colour were contingent – colour inescapably affecting the form that contains it. This notion had been expounded by Adrian Stokes in his *Colour and Form* (1937), which corrected Roger Fry's theory of 'significant form' by introducing the formal, sensory and emotional effects of colour.

Like Kandinsky, Frost used colour as a tool in his attempt to evoke emotion through painting: in such works as *Blue Movement* 1953 it was both illustrative and evocative. He believed in its innate emotional force and jotted in his notebook Ruskin's observation that:

> All men completely organized and justly tempered enjoy colour, it is meant for the perpetual comfort and delight of the human heart, it is richly bestowed on the highest works of creation, and the eminent sign

and seal of perfection in them, being associated with *life* in the human body, with light in the sky, with purity and hardness in the earth.[1]

If colour had previously served a figurative as well as sensory purpose for Frost, the works made after the mid-1960s were based upon the emotive power of pure colour and abstract form. He conceived of colours in absolute terms, and desired to separate them from possible external associations:

> I'm OK on reds and blues and yellows I can almost do it in my mind, but the greens take some holding on my mind screen. Perhaps I've never got green free, i.e. from the sea and landscape. I must get it free for itself as green, or a particular green, otherwise I'll never get it to be as responsible as the green in nature. A colour is no good unless it takes full responsibility for its yellowness or blueness etc.[2]

As we have seen, Frost often used a limited number of pure, contrasting hues. At the same time, he became interested in the range within a single colour and the subjective nature of perception. He has described how, in the late 1960s, he asked his students to investigate the boundaries of colour by mixing different blacks. They used red, yellow and blue, gradually increasing the amount of one colour until it 'broke' through, then following the same process with each of the others. He then told them to identify the colour they considered to be 'mid black'; the result was, he said, 'the greatest lesson of my life, when we put them up there wasn't one like the other. Now this means that colour is totally subjective.'[3] Frost did the same thing, taking six large canvases, dividing them up into fifteen-by-nine-inch blocks, and painting each section a different black. He then cut out rough semicircles from each and collaged those onto a larger canvas (fig.48).[4] The result is a composition in which red-blacks, green-blacks and blue-blacks harmonise and contrast with each other, and in which the ground and space between them becomes an active component. Over several years he made a number of these, a second *Through Blacks* and *Through Yellows*, *Reds*, *Blues* and *Greys*.

In the early 1980s, this series was taken further with *Through Whites* (fig.49), which was accompanied by a number of 'White Out' paintings. In an echo of the 1950s, these were inspired by a visit to Canada, during which Frost drove through a blizzard so severe that the car seemed entirely engulfed by white. If *Through Whites* is made up of a couple of different whites within discrete areas defined by sparingly-painted black lines, *Canada Whites* (1985–6) consists of

50
Newlyn Rhythms
1981–8
Acrylic and collage on
twenty canvases
223.5 × 279.5
Private collection

numerous whites, some towards pink, others a very pale blue, and so on. It is a triptych, but in each of the three panels the various colours are confined within half-ovals, which are themselves arranged within rhombi that appear to extend from one canvas to the next; the forms conjoin in such a way as to establish a sinuous linear effect. A similar effect is seen in *Newlyn Rhythms* (fig.50), in which harmony and contrast of colours and forms can be varied by rearranging the twenty canvases that make up the whole work. In a manner typical of so much of his production over the years, Frost combines a formal structure with the overall sinuosity that had emerged in the art of the 1950s following the impact of Jackson Pollock. *Newlyn Rhythms* was, perhaps, the largest of a number of similar paintings from the 1980s and 1990s, in which small areas of pure colour interact in a polychromatic hurdy-gurdy.

In their almost total refusal of any external associations, the 'Through paintings' were among Frost's most non-figurative works. Their repetition and variation of the semicircle seems deliberately to avoid the expected implication of a boat. At this time Frost was passionate in his dismissal of the figurative painting of the Coldstream tradition, by then epitomised by his near-contemporary at Camberwell, Euan Uglow. He was, in particular, disgusted 'at that type of painting being hoisted on the old flag of "commitment and integrity"':

> It is the opposite of love, it is hate through ignorance and a total misunderstanding of art, a safety net of false intellectualism. It is away from life, from reality, away from the spiritual, there is no magic, no connection with the 'spirit', no poetry, just dull academic 'rightness'.[5]

In contrast, colour was a medium of mystery and spirituality. Certain hues, he would say, 'have depth and "life" and can take you through a spiritual journey'.[6] Art was part of the mystery of human existence and abstract art offered a means of contemplating those non-material dimensions. While 'the spiritual and subjective emotions tend to be suppressed by the weight of scientific or mathematical learning', art opens them up, he believed:

> If we dare to feel, if we dare to let our intuition or inner self really see, then we know we are mystery and art is part of our mystery … logic is just a safety curtain to stop humans from feeling for the true inner light. Lift the curtain and see, stand in front of your next abstract and be true and feel and see for yourself.[7]

Addressing the question of Matisse's belief that art was an armchair for the tired businessman, Frost believed that his brightly coloured abstract paintings were not simply decorative. 'To look at a painting which gives you the opportunity to have solitude, to be yourself and to be able to wander into reverie,' he wrote, 'is more than hedonistic, it's spiritual.'[8]

For Frost, the spiritual was especially richly invested in black. In terms of colour, black holds everything and nothing, it is both joyous and mournful. Its qualities were summarised in one of Frost's favourite poems, *Sonnet to Black*, by the seventeenth-century politician and occasional poet, Lord Herbert of Cherbury:

> Thou Black wherein all colours are composed
>> And unto which they all at last return;
> Thou colour of the sun where it doth burn
>> And shadow where it cools.

The duality of black seems to inform several paintings which feature a 'black sun', a motif borrowed from Kandinsky that echoes Herbert's verse and reflects the artist's interest in the visual perception of natural phenomena. A related work, *Circle of Love* (fig.51), indicates how the form of the circle also stands as a symbol of wholeness.

The idea of a black sun is both poetically resonant and derived from an actual perceptual phenomenon: the brightness of the sun making it appear dark if looked at. Frost became increasingly taken with the idea of natural forms being emblems of abstract forces. The sun and moon became his 'two gods', a phrase that echoed Robert Graves's call, in *The White Goddess*, for a return to true poetry that is inspired by the moon (the goddess of the title).[9] Poetry had fascinated Frost since he had first read it in depth as a prisoner of war. Later he was encouraged by friendships with James Kirkup at Corsham, Jon Silkin and Thomas Blackburn in Leeds and, most especially, with W.S. Graham, one of his closest companions in Cornwall. Frost's list of favourite poets, or poems, largely consists of major figures, both innovative and traditional: Auden, Shelley, Keats, Ezra Pound, Thomas Hood, Walter de la Mare, Robert Frost, Dylan Thomas, Roy Campbell, Lawrence and Wordsworth.[10] There is a parallel between the painter's use of allusive forms and colours and poetic imagery, and it is not surprising that he should prefer poetry that is especially dependent upon

conceit and simile, such as that of John Donne. Furthermore, his belief in 'moments of truth' was close to the Romantics' drawing of inspiration from certain objects or momentary events, as seen in Wordsworth's *Daffodils*. While such comparisons are sustainable at the more general level of the different arts' conventions and techniques, Frost was also attracted to poems in which colour is prominent among the imagery. This had been seen early on in his use of Auden's 'O lurcher-loving collier, black as night', and was repeated in 1974 in a number of paintings based upon Pound's colourful *The Game of Chess*.[11]

It is not surprising that, as he was drawn more towards poets and their work, his painting became more figurative than the abstractions of the 1970s. Specifically, as the 'black sun' paintings had anticipated, he was once again fascinated with the sea and the sun. The revival of marine motifs reflected a change in Frost's circumstances: he decided to return to Cornwall and, in 1974, bought a house perched on the hill that rises steeply above the fishing town of Newlyn. From there he could look down onto the harbour and out across the blue of Mounts Bay, to St Michael's Mount on one side and out to sea on the other. Rising early, he watched the sun come up at dawn and, in the evening, saw it set and the moon rise in its place.

51
Circle of Love
1975–9
Acrylic and collage
on canvas
156.2 × 142.2
Collection of the artist

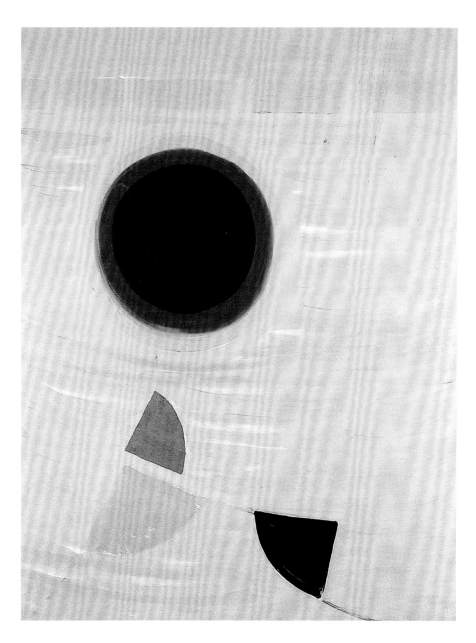

52
Black Sun
1982
Acrylic on canvas
215.9 × 165.1
Private collection

He was, in his own words, 'caught between two gods'. These phenomena, the sun and moon rising and setting, became natural symbols of a spiritually inflected universe and frequent subjects for his art. This was further encouraged by his familiarity with the Mediterranean. He visited Spain and, from 1977, became a frequent visitor to Cyprus and other Greek islands. Inevitably, Frost was exhilarated by the rich colours and stark whites that were brilliantly enhanced by the summer sun. The sea, the sun, and its reflection, rendered in a range of blues, reds, oranges and yellows, became the principal motifs of his paintings of the 1980s. He observed such effects as the green after-image left when the sun finally dips beneath the horizon, and sought to express it in paint. To these rich new stimuli were added old motifs, revived, perhaps, by the return to Cornwall. In such works as *Black Sun* (fig.52), half and quarter-circles once more signified the moored boats rocking in the harbour.

In some of these paintings, rich black circles are arrayed across the polychromatic fields, and Frost explained that these forms were suggested by black olives. For him, the dark, bitter olives came to stand for the whole experience of the Mediterranean: 'if we are dealing with black olives,' he wrote,

> we are not thinking of colour theory at all – it is to do with the event …
> an idea of olives which carries for the whole experience of life and
> friends in Cyprus … of black olives, of suns and moons to strange
> smells, new country, the dance, everything is mixed up in this.[12]

So, a formal device that stresses the flatness of the picture surface, in defiance of the imagery of sun and sea, is also seen to epitomise, or embody, the exotic richness of Mediterranean culture. Perhaps the rich simplicity for which the olives stood offered a welcome respite from the disaffected and disappointed Britain of the 1970s.

With his evocation of the Mediterranean through certain resonant objects and colours, it seems inevitable that Frost should have been drawn to the Spanish poet Federico García Lorca. Often seen as Spain's greatest modern poet, Lorca was born in 1898 and was murdered by Nationalists in 1936. His work is known for its emotional intensity and rich metaphors, as he brilliantly evokes a culture, through the observation of its details, in a poetry that is always informed by an awareness of death's constant presence. Frost

53
Blue for Newlyn
1989
Oil and collage on canvas
226 × 139.5
Private collection

had first read Lorca in the early 1970s, drawing upon it for his own work. It became an especially important theme during the 1980s, when, as well as numerous related paintings, in 1989 he produced a portfolio of prints: *Eleven Poems by Federico García Lorca* (fig.54). These combined a familiar semi-abstraction with more literal representation and certain well-established symbols, such as the heart-shape. The relationship to the verse is similarly variable, at times coming close to illustration, at others more allusive. *Lament for Ignacio Sanchez Mejias*, for example, combines a subtle reference to the bull's horn with a more literal suggestion of the toreador's blood that it spills in Lorca's haunting elegy. The image works formally whilst successfully conjuring up the blinding sun of the poem.

One particular aspect of Lorca's poetics seems especially relevant in a discussion of Frost's work: the concept of the *duende*.[13] The *duende* is a rooted spirit that informs the best cultural creations, most particularly in music, dance and spoken poetry. 'All that has black sounds has *duende*,' wrote Lorca:

> These black sounds are the mystery, the roots fastened in the mire that we all know and all ignore, the mire that gives us the very substance of art … the spirit of the earth … Every man and every artist … climbs each step in the tower of his perfection by fighting his *duende*.[14]

The *duende* is the awareness of death that is necessary to the full engagement with life, and to a spiritually-enriched, rooted, passionate cultural form. In contrast to the muse and the angel, who flee and lament death,

> the *duende* does not come at all unless he sees that death is possible … With idea, sound or gesture, the *duende* enjoys fighting the creator on the very rim of the well … the *duende* wounds. In the healing of that wound, which never closes, lies the invented, strange qualities of a man's work.

Inspired art is born of the artist's struggle with the *duende*, the use of technique to overcome its irrationality; it is a metaphorical fight with, and so acceptance of, death.

Frost spoke of experiencing the *duende* in a Spanish fish market:

> I thought what are they all doing in black? I thought people would wear white for the heat … Then they slithered a great silver fish in front of me!

54
Lament for Ignacio Sanchez Mejias
1989
(etching from **Lorca** portfolio)
56.5 × 38.4
Private collection

Then they began to carve it up. What with the sound of the Spanish, which was beautiful to me, and then this silver fish – it was a magic moment.[15]

The theory of the *duende* endorsed the ideas that had long informed Frost's art. After all, it had affinities with the catharsis of Greek tragedy, and with notions of the Sublime. In each, life is enhanced by a confrontation with suffering or premonitions of death. Those 'moments of truth', experienced on the quay in St Ives, or in the snow-bound Yorkshire Dales, were instances when delight in the enormity of nature also made Frost aware of his own minuscule vulnerability. Similarly, his art had long exhibited aspects that Lorca would associate with the *duende*: a dialectic of control and disorder, reflecting the artist's paradoxical respect for form and attraction to chaos, seen in his simultaneous use of geometry and willingness to break out of it.[16] Frost's themes are Lorca's too: vivid colour, the sun and moon, an earthy awareness of the body, an implicit eroticism and unstated consciousness of death.

5 in the Afternoon (Lorca) (fig.55) takes its title from the time at which the toreador Ignacio Sanchez Mejias met his death, and from the phrase with which Lorca's elegy tolls his passing. In the painting, patches of red and black seem to

55
5 in the Afternoon (Lorca)
1989
Oil on canvas
76 × 61
Private collection

hover like clouds, a louring presence of death; hanging from them, a black line provides the composition with a spine, whilst slyly indicating the hour of the title. Three chevrons seem, at once, to enter the canvas from the right and to be ready to fly off again: they introduce a formal tension and the hint of a female eroticism, whilst recalling, perhaps, the black crows which flew from van Gogh's last painting, as if a presentiment of the artist's imminent death. In a painting of eloquent simplicity, Frost thus conjoined, with characteristic ambiguity, visual delight, the erotic and an intimation of mortality.

The *Lorca* portfolio was perhaps the most successful group of the many prints that Frost produced in later years. Indeed, during the 1980s and 1990s, printmaking could almost be said to have become his principal activity, as he produced numerous sets of wood and linocuts, etchings, lithographs and screenprints. He had made prints since the late 1940s, and had worked with some of the finest printers in Britain and Europe, but now this activity could be seen as part of a larger financial operation. As well as a growing popularity, a number of practical considerations forced Frost to increase his output. Despite the optimism of his retirement and an important retrospective exhibition in 1976, the late 1970s and early 1980s saw a series of personal setbacks. There were complications with the Inland Revenue; then, he not only left the Waddington Galleries with some bitterness, having been advised, after twenty years, to try elsewhere, but found that he owed them money. In 1980, he showed at the New Art Centre and, for the first time, failed to sell a single painting; in 1982, he had trouble getting his work back from Vancouver when the gallery there went bankrupt; and in the same year he sold nothing from an exhibition in London, Ontario, and only four works from a display of gouaches. Having hoped to retire and live solely from his art, he was once again dependent on the income from teaching.

In 1976, a retrospective exhibition that toured Britain, including the Serpentine Gallery in London, had afforded an opportunity to review thirty years of production. It was well received. The critic of the *Sunday Telegraph*, for instance, saw in the recent work 'straightforward expressions of joy ... a painter's second childhood', and recognised the 'unpretentious, happy independence ... of Frost's art' as a veteran's dream.[17] In contrast, within a few years, the artist found himself confused, unable to see a way out, and unsure if he had 'the strength to survive the cruel financial situation'. Finding his confidence in his work sorely tested, Frost was at his lowest ebb. 'Life is becoming increasingly touchy and fragile,'

he noted, 'I am now a dead loss, a loser, a nuisance. My worries have eaten into me and I think it would be better for everyone if I disappeared.'[18]

His departure from Waddingtons, however, was soon followed by a revival of interest in the artists of St Ives. Frost proved to be a skilful promoter of his own work and, through exhibitions at several commercial galleries, he re-established a market for both his past and new paintings. In addition, as well as many prints, he embarked upon a range of other projects: from the late 1970s, he produced jewellery and ceramics; later he designed watches and other items for sale at the Royal Academy, to which he was elected in 1998; in the 1990s he collaborated with a Murano glass maker, and was one of several artists controversially commissioned to redesign the tail-fins of British Airways' aircraft.

The effect of the difficulties of the early 1980s may be reflected in Frost's painting. The return to a sort of figuration, with the representation of the sun reflected on a boat-bobbing sea, involved a certain awkwardness, a tension between figuration and the formal values which had been one of the great strengths of Frost's work. Similarly, the return to earlier motifs – such as the boat forms – and the occasional resort to visual clichés, for example the hearts that appeared in some images, suggest an interruption to the artist's formal invention. Alongside these works, however, Frost continued to produce simpler images, and it was this strand that he developed during the 1990s. *Suspended Forms Triptych (Red, Yellow and Blue)* (fig.56), for example, revives the artist's interest in apparently bulging, weighty forms with a simple monumentality and the rhythm of repeated forms in different colours. Formal repetition would become a common feature.

The illusionistic suspension of forms was made literal in a number of works of the 1990s, to which Frost attached red, black and white discs. These related to the black olive motif that had served to emphasise the picture plane, but now defined a shallow space literally in front of the canvas (fig.57). In a similar vein, the artist produced several sculptures which were rocking wooden structures, painted white, with black and red discs attached. These various works also signalled the reassertion of Frost's love of red, black and white, a simple combination that had first appeared in his work in Leeds in 1955 and which seems to have been reinvigorated by the Lorca pictures. These three colours and the exploration of actual, shallow space were also combined in a series of squeezed works, in which the

56
Suspended Forms Triptych
(Red, Yellow and Blue)
1989
Acrylic and collage
on canvas
142.2 × 182.9
Collection of the
artist's estate

57
White Hot
1993
Acrylic, oil and
collage on canvas
106.7 × 106.7
Private collection

58
Installation of Spirals
1991
Acrylic and collage
on forty canvases
each 63.5 x 63.5 or
190.5 x 190.5
Private collection

composition is traversed, or two forms are connected, by a piece of card folded, concertina-like, to present many planes protruding into the viewer's space. Combining simple, plainly coloured forms with more painterly gestures, these related to an unrealised design for an opera set.

For some of the boldest works of later years, Frost reverted to a form that was not only one of the earliest in his own work, but one of the most fundamental in visual culture: the spiral. He painted spirals of black and another colour curling around a field of white; masses of small spirals on a field of the same colour; or, single red spirals on red, blue on blue, white on white, and so on, like dynamic parodies of the monochromatic canvases which, in the 1960s, had brought Hilton's abstraction to a crisis. Many were single spirals filling the frame, some were paired, some of more than one canvas conjoined to form a polyptych. The arrangement (variable or fixed) of many canvases, which Frost had used with his *Newlyn Rhythms* 1981–8, became a common feature of larger works. *Spirals* (fig.58), for example, can consist of a variable number of canvases which may be configured in different ways. A similar spiral had appeared in the *Construction* 1951–2, at a time when it was also a feature of Pasmore's work, and similarly simple, yet dynamic, forms had reappeared over the

years. Though they were apparently inspired by a visit to the seemingly timeless landscape of the Arizona desert, Frost was also aware of their use by many early cultures, and particularly of their role in Celtic art. His statement, 'spirals are forever', suggests both their holistic, apparently endless form, and their longevity as a symbol. He went on to say, however, that, as a result, 'you know that you belong to forever'.[19] Again, apparently decorative motifs were employed as symbols of one's place in existence.

So, many of Frost's late works showed a refined simplicity, a reduction to primary colours and one of the most ancient of visual forms. Typically, as a result, they combine a joyful dynamism with an invocation of the natural and of ancient culture. As Frost approached his eightieth birthday, his work seemed to become even more celebratory and Dionysian. When the new Tate Gallery opened in St Ives in 1993, he made a long banner of brightly coloured spirals, surrounded by radiating sun-burst lines, to hang down the apsidal stairwell. Positioned next to a high window onto the sky, it seemed to challenge the sun at its own game. Similarly, a touring exhibition in 1995 was a cacophony of colour, as large canvases were joined by brightly decorated Chinese lanterns and stuffed tubes which spiralled down from the ceiling, filling the space of the room. It seemed as if old age made Frost's output not merely more colourful but more audacious in its simplicity and its combination of discordant and complementary colours. While the techniques learnt at Camberwell fifty years before still proved useful, the brilliance of the Cornish and Mediterranean sun remained an abiding theme. *Sunblast* (fig.59), with its dashes of paint radiating out from the yellow-white centre of the sun, epitomises Frost's abiding love of strident colour and dynamic form.

Terry Frost's work remained as exuberant and extravagant in its undiluted colour and uninhibited form as it ever was. His last major visual statement was probably his most ambitious work and seemed like a summary celebration of one of his great passions: the primary combination of red, black and white. For an exhibition at Tate St Ives in February 2003 (fig.60) he produced an installation that occupied a whole room. On one wall a huge black and red spiral on a white background was framed by twenty-six smaller canvases, each combining the three colours; opposite were four interlocking canvases and across the floor eight cubes of varying sizes were arrayed, each painted red, black or white. The forms in the paintings seemed like a glossary of Frost's favourite themes: spirals, semi-circles,

shallow arcs, triangles; rocking boats, sun and moon, olives; acrylic paint, charcoal, collage. It was a jubilant auto-retrospective, a celebration of the pleasures in, and of, sixty years of painting.

As his exhibition opened in St Ives, Terry Frost was diagnosed with cancer. He died on 1 September 2003, painting until his last days. The reporting of his death in newspapers and broadcast news programmes around the world was an acknowledgement of his huge popularity, testament to his success in bringing pleasure to a broad constituency.

He had successfully founded a career upon his belief in the universality of responses to not only colour and form, but also the sun and the moon. This faith in intuitive reactions underpinned his dismissal of art as direct communication; how could he subscribe to a literary art when, echoing Gaston Bachelard, he felt that even the first mark on the canvas 'clips the wings of imagination'?[20] As the poet loves and uses words and phrases in all their aspects, so Frost revelled in colour, form and brushwork. He was immensely prolific and, inevitably, some works, or groups of works, seem less successful than others. But, despite its flamboyance and vivacity, his painting does not lack rigour. Developing from his original training and early use of geometry,

Frost retained a sense of the importance of compositional control, though this frequently remained overshadowed by his use of colour and far-reaching excavation of his imagination. However much his love of red, black and white invoked the memory of Malevich and Lissitzky, he was unquestionably the inheritor of the tradition of Matisse and, even more so, of Robert Delaunay.

Nevertheless, one must not let the art's joy, or the artist's playful accounting of it, obscure its serious purpose. It was not simply, as Frost transcribed from Dostoyevsky, that 'the world will be saved by beauty'.[21] Rather, he used colour and form to communicate to the viewer the intense emotional experience of being in the world, most often, of being in front of nature. The anecdotes with which Frost enshrouded his art recount what he called 'moments of truth', instances when some sublime experience offered a passing glimpse of his own place in existence; or, as he would have it, 'of forever'. His description of a visit to the small Cornish cove of Nanquidno summarises the issues at stake:

> twilight … quiet of sound except the wind and sea shore swish, my surprise at suddenly seeing a blood red circle about to descend into the full-bellied sea. I turned to tell my companion and my speech was trapped by a black silhouette of a hill behind which was creeping up, the biggest circle of nearest orange. Wow. Trapped again between two gods. It's for me a moment of fear, of excitement, of breath-stopping awe … that contact with forever, being part of everything and being nothing.[22]

Just as art provided Frost with a creative freedom after the miserable restrictions of imprisonment, so he employed it, and this personal mythology of magic moments, to communicate the awesomeness of existence. Despite the works' polychromatic *jouissance*, this entailed the recognition of one's own minuscule position in the universe and, by association, the unavoidable reality of mortality. The work is all the more brilliant for immersing itself in, and shining from, the mire.

60
Installation: Contrast in
Red, Black and White
2003
1 canvas 228.6 × 228.6,
25 canvases each 76.2
× 76.2 and eight painted
hardboard cubes
Martin Krajewski Collection

NOTES

TGA = Tate Gallery Archive

INTRODUCTION

1 Undated manuscript.
2 Conversation with the author, 18 Jan. 1993.
3 John Hubbard, 'Preface', in *Terry Frost: Paintings, Drawings and Collages*, exh. cat., Arts Council/South West Arts 1976–7, p.3.
4 'Postscript', in David Lewis, *Terry Frost: A Personal Narrative*, Aldershot 1994, p.233.
5 Undated manuscript.

UNEXPECTED BEGINNINGS

1 Miscellaneous autobiographical writings, TGA 7919.2.1.
2 Interviews with David Lee, June 1993, and David Lewis, Oct. 1993, in Lewis 1994, p.29.
3 Miscellaneous autobiographical writings, TGA 7919.2.1.
4 Flt Sgt R. Heard, undated press cutting [June 1944].
5 Ibid.; interview with David Lewis, Oct. 1993.
6 Interview with David Lewis, Oct. 1993.
7 Ibid.
8 Notes, Banbury mid-1960s, published in broadsheet for *Terry Frost: Painting in the 1980s*, University of Reading 1986.
9 Heard [June 1944].
10 Interview with David Lee, June 1993.
11 Miscellaneous autobiographical writings, TGA 7919.2.1.
12 Interview with David Lewis and Sarah Fox-Pitt 1981,

in Lewis 1994, p.36.
13 Sven Berlin, quoted in Peter Davies, 'Notes on the St Ives School', *Art Monthly*, no.48, July/Aug. 1981, p.3; Frost, interview with David Lewis, Dec. 1991, Lewis 1994, p.36.
14 Interview with David Lee, June 1993.
15 Ibid.
16 Ibid.
17 Interview with David Lewis, July 1993, in Lewis 1994, p.42.
18 Letter to Yan Kel Feather, n.d. [c.1949/50].
19 Interview with David Lee, June 1993.
20 Letter to Feather, c.1949/50.
21 Letter to Feather, n.d. [?1950].
22 Ibid.
23 Letter to Ben Nicholson, n.d. [?1950], TGA 8717.
24 Interview with David Lewis, July 1993, Lewis 1994, p.44.
25 Ibid.

THE ABSTRACTION OF EXPERIENCE

1 Letter to Yan Kel Feather, n.d. [c.1949].
2 E.C. Gregory, letter to Ben Nicholson, copy in Frost papers.
3 Peter Lanyon, 'Time Space and the Creative Arts', manuscript, Dec. 1948.
4 Miscellaneous autobiographical writings, TGA 7919.2.1.
5 Lecture notes, n.d. [1955/6].
6 Interviews with David Lewis, Dec. 1991, July and Oct. 1993, in Lewis 1994, p.39.
7 7 'St Ives', undated manuscript.
8 Interviews with David Lewis, Dec. 1991, July and Oct. 1993, in Lewis 1994, p.39.
9 Ibid.

10 Transcript of Terry Frost talking with Adrian Heath and John Hoskin for the soundtrack of a film about the artist, July 1987.
11 Lecture notes, n.d. [1955/6].
12 Interview with David Lee, June 1993.
13 Lecture notes, n.d. [?1955/6].
14 Ibid.
15 Patrick Heron, 'Space in Colour: Notes on Nine British Painters', *Arts Digest*, vol.29, no.12, 15 March 1955, p.10.
16 Quentin Bell, 'Round the London Galleries', *Listener*, vol.48, no.1233, 16 Oct. 1952.
17 *Times*, 13 Oct. 1952.
18 'Paintings by Terry Frost at the Leicester Galleries', *New Statesman and Nation*, vol.44, no.1127, Oct. 1952, p.420.
19 This information is drawn in large part from Alastair Grieve, 'Towards an art of environment: exhibitions and publications by a group of avant-garde abstract artists in London 1951–5', *Burlington Magazine*, vol.132, no.1052, Nov. 1990, pp.773–81.
20 Adrian Heath, *Abstract Art: its Origins and Meaning*, London 1953.
21 Interview with David Lewis, Oct. 1993, in Lewis 1994, pp. 54–5.
22 Heath 1953, p.6.
23 Draft letter to Victor Pasmore, n.d., artist's notebook.
24 Kenneth Martin, letter to Terry Frost, 21 July 1953, TGA 7919.3.4.
25 Undated notes [c.1954].
26 Lawrence Alloway, *Nine Abstract Artists*, London

1954, pp.12–13.

27 Ibid. pp.23–4.

THE NEW SUBLIME

1 Lewis 1994, p.57.

2 Patrick Heron, 'London', *Arts*, vol.30, no.7, April 1956, p.73.

3 Letter to Lawrence Gowing, 27 Dec. 1956.

4 Draft letter to Lawrence Alloway, n.d. [1957].

5 Letter to Claude Rogers, n.d. [1965], TGA 8121.

6 Transcript of Terry Frost talking with Adrian Heath and John Hoskin for the soundtrack of a film about the artist, July 1987.

7 Interview with David Lewis, July 1993, in Lewis 1994, pp.73–6.

8 Terry Frost, letter to Colin Painter, 1977, TGA 7919.3.5.

9 Ibid.

10 Artist's notebook, c.1975, in Lewis 1994, p.66.

11 Patrick Heron, 'London', *Arts*, vol.32, no.1, Oct. 1957, p.17.

12 Patrick Heron, 'The Americans at the Tate Gallery', *Arts*, vol.30, no.6, March 1956, p.16.

13 In common with all of the works in the exhibition *Modern Art in the United States*, these two paintings are in the Museum of Modern Art, New York.

14 Heron, March 1956, p.16.

15 Heron, April 1956, p.12.

16 Transcript of Terry Frost talking with Adrian Heath and John Hoskin for the soundtrack of a film about the artist, July 1987.

17 See, most notably, Robert Rosenblum, 'The Abstract Sublime', *Artnews*, Feb. 1961, p.39ff.

18 Undated manuscript.

19 Undated manuscript, Leeds, TGA 7919.2.1.

20 Mike von Joel, 'Still Crazy After All These Years', *Art Line*, vol.4, no.8, 1989, p.20.

21 Roger Hilton, letter to Frost, n.d. [c.1955–6], TGA 7919.3.3.

22 Undated notes.

COLOUR AND FORM

1 Letter to Yan Kel Feather, 1 March 1960, in Lewis 1994, p.85.

2 Letter to Tate Gallery, Oct. 1984 in David Brown, *St Ives: Twenty-five Years of Painting, Sculpture and Pottery*, London 1985, p.201.

3 3 Interview with David Lewis, July 1993, in Lewis 1994, p.78.

4 Ibid.

5 Terry Frost, Belgrave Gallery, London 1989, no.19.

6 Transcript of Terry Frost talking with Adrian Heath and John Hoskin for the soundtrack of a film about the artist, July 1987.

7 Ibid.

8 Roger Hilton, letter to Frost, n.d. [?1963], TGA 7919.3.3.

9 Draft letter to Roger Hilton, n.d. [?1963], TGA 7919.

'MOMENTS OF TRUTH'

1 Transcribed by Frost from John Ruskin, *Modern Painters, London 1843– 60*, notebook, n.d.

2 Artist's notebook, n.d. [1970].

3 Interview with David Lee, June 1993.

4 The first of these was *Through Blacks* (1969), Tate Gallery.

5 Artist's notebook, n.d. [1970].

6 Artist's notebook (12).

7 Undated notes.

8 Transcript of Terry Frost talking with Adrian Heath and John Hoskin for the soundtrack of a film about the artist, July 1987.

9 Robert Graves, *The White Goddess*, London 1948.

10 List from undated notes, TGA 7919.2.7.

11 See Lewis 1994, pp.121–2.

12 Artist's notebook (4) and transcript of Terry Frost talking with Adrian Heath and John Hoskin for the soundtrack of a film about the artist, July 1987.

13 This has been discussed at greater length by Linda Saunders, 'Frost and the Duende', *Green Book*, vol.3, no.3, 1989, revised version in Lewis 1994, pp.217–24.

14 Federico García Lorca, 'Play and Theory of the Duende' (1933), in *Deep Song and Other Prose*, trans. Christopher Maurer, London and New York 1980, p.43.

15 Quoted in Saunders 1989/1994.

16 This point is made in Saunders 1983/1994.

17 Michael Shepherd, 'A Warm Frost', *Sunday Telegraph*, 20 Feb. 1976.

18 Artist's notebook, 1980, in Lewis 1994, p.146.

19 Interview with David Lee, June 1993.

20 Quoted in Saunders 1983/1994.

21 Recorded in notebook [c.1972].

22 Undated manuscript.

SELECT BIBLIOGRAPHY

(In chronological order)

Frost, Terry, 'Statement' in Lawrence Alloway, *Nine Abstract Artists*, London 1954, pp.23–4

Heron, Patrick, 'London', *Arts* (N.Y.), April 1956, pp.12–13

Heron, Patrick, 'London', *Arts* (N.Y.), October 1957, pp.16–17

James, Philip, 'Introduction' in *Terry Frost: Retrospective Exhibition*, exh. cat., Laing Art Gallery, Newcastle upon Tyne 1964

Brown, David, 'Introduction' in *Terry Frost: Paintings, Drawings and Collages*, exh. cat., Arts Council/ South West Arts 1976

Frost, Terry, 'Extracts from a Painters's Notebook', *Aspects*, no.1, 1977

Davies, Peter, 'Notes on the St Ives School', *Art Monthly*, no.48, July/Aug. 1981, pp.3–8

Lewis, Adrian, 'British Avant Garde Painting 1945–56', *Artscribe*, nos 34 and 35, May and June 1982

Brown, David (ed.), *St Ives: Twenty-five Years of Painting, Sculpture and Pottery*, exh. cat., Tate Gallery, London 1985

Heath, Adrian, 'Recollections and Movements' in *Terry Frost: Painting in the 1980s*, exh. cat., University of Reading 1986

von Joel, Mike, 'Still Crazy After All These Years', *Art Line: International Art News*, vol.4, no.8, 1989, pp.16–23

Duncan, Ronnie, 'Introduction' in Terry Frost: Paintings 1948–89, exh. cat., Mayor Gallery, London 1990

Lee, David, 'Terry Frost: an Interview', *Art Review*, vol.45, June 1993, pp.4–8

Lewis, David, *Terry Frost*, Aldershot 1994

PHOTOGRAPHIC CREDITS

COPYRIGHT CREDITS

INDEX